PATERSON
THROUGH TIME

MARCIA DENTE

FOREWORD BY CONGRESSMAN
WILLIAM J. PASCRELL, JR.

AMERICA THROUGH TIME®

AMERICA THROUGH TIME is an imprint of Fonthill Media LLC

Fonthill Media LLC
www.fonthillmedia.com
office@fonthillmedia.com

First published 2013

ISBN 978-1-62545-057-9

Typeset in Mrs Eaves XL Serif Narrow
Printed and bound in England

Connect with us:
www.twitter.com/USAthroughtime
www.facebook.com/AmericaThroughTime

AMERICA THROUGH TIME® is a registered trademark of
Fonthill Media LLC

INTRODUCTION

Paterson is the third largest city in the state of New Jersey and the County Seat of Passaic County. There are exceptionally few cities that exude as much history as Paterson does. It was envisioned by one of our founding fathers, Alexander Hamilton, as an industrial city. It was a place where things were made. Hamilton remembered the site of his picnic on July 10, 1778 with George Washington, the Marquis de Lafayette and James McHenry overlooking the Passaic Falls when searching for a place conducive to building manufacturing in the United States. In helping to found Paterson Hamilton made it a city of 'firsts'.

Here the engine that powered the Spirit of St Louis was created; Henry Bacon, architect of the Lincoln Memorial, laid out his vision of the Danforth Memorial Library; John Holland, an Irish immigrant, perfected the modern submarine in peacetime, making underwater navigation possible (1878); Alexander Hamilton walked the paths near the Great Falls dreaming of an industrial city and breaking its ties with England; Pierre L'Enfant, creator of the Washington D.C. streetscape, created Paterson's industry-crucial raceways. Vice-President Garret A. Hobart came from Paterson as did Lou Costello of Abbott and Costello fame. It was home to Larry Doby who in 1947 broke the color barrier in the American League, moved to Paterson in his early teens and became a legend here. There were others who lived their own dreams, large and small.

Paterson was one of America's first centers of industry and has a proud history of 'firsts' in American business: Samuel Colt manufactured the first Colt .45 revolver in Paterson in 1836; water-powered cotton spinning mill (1793); continuous roll paper (1812) and the Rogers Locomotive Works which helped fuel western expansion through the transcontinental railroad (1837).

The silk mills and other textile facilities sprang up. Owners made their fortunes; workers, often immigrants, made a living. Still known as the 'Silk City' today, prominent industrialist John Ryle successfully proved that weaving silk could be a profitable business and set out to build international recognition for his products. In Ryle's day Paterson hummed with the silk industry and was an international melting pot thanks to a constant influx of workers and immigrants from around the globe. And in 1913, seeing its share of labor unrest, the Industrial Workers of the World (IWW) helped stage the 'Paterson Silk Strike', fighting for an eight hour work day and other concessions from factory owners and prominent industrials.

It was out of this cauldron of activity that an entire generation of achievers emerged. Among those born in the 1920s and raised in Paterson were poet Allen Ginsberg, Jazz guitarist Bucky Pizzarelli, and Lou Duva, a famous boxing manager and promoter. Paterson was central to poets like Ginsberg and William Carlos Williams—the beauty of the Great Falls an inspiration celebrated in verse.

It was the launching point for many in public service such as the late Senator Frank Lautenberg, Congressman William J. Pascrell, Jr., Senator Robert Menendez, and William

Simon, deputy treasury secretary in the Nixon administration. And it was a sure-fire political stop for everyone from Hoover to Eisenhower to Kennedys (both JFK and Ted), Reagan, Carter, Bush (President George H. W. Bush) and presidential hopefuls, Walter Mondale and Gary Hart. Martin Luther King Jr. visited the Community Baptist Church just days before his assassination in 1968 and Gerald Ford, standing in the rain at the Great Falls, designated 119 acres surrounding the Falls a national historic landmark in June 1976 and in March 2009, President Barack Obama signed into law the Paterson Great Falls National Park Act.

Paterson was the gem in the crown of the American Industrial Revolution, a city of unmistakable value, not only for its industrial production, innovative design and inspiring pioneers, but for its unyielding strength, surviving numerous floods, fire, a tornado and the crime and poverty that still plague its people today. Paterson has always been rich, not in terms of monetary value, but in the spectrum of cultures reflected by its ever diverse and growing population.

Though the last names have changed and the factories have since closed, the shadow of Paterson's past can still be seen today in the remnants of the silk mills and dye houses, the grand architecture that lines the Downtown and Eastside sections; it can still be heard in the echoes of the majestic Great Falls and the crowded streets that have developed around it. Paterson has always been home to a working class of many different cultures and creeds as can be seen in the hundreds of houses of worship that grace the city and perhaps thousands of ethnically inspired eateries that stretch across Paterson's fourteen zip codes.

While the last two centuries may have dulled its shine, its resilience remains. Despite its current unfortunate reputation among the surrounding suburban towns, Paterson remains both unbreakable and immovable from its place in American history as Patersonians continue to defend their home with pride. The skyline of steeples and smokestacks not only frames its past which honors its motto *Spe Et Labore* ('Hope and Labor'), but the extended landscape surrounding the historical center is a testimony to Paterson's influence. There would be no suburbs without this urban core.

Part of Paterson's charm are its natural features. Its spires and smokestacks poke up from a shallow, embracing bowl. A river flows through it and a small mountain frames it on one side. Before Route 80 cut it off from the city, this mountain was where poets and millionaires could walk to gaze down on the great metropolis. Paterson is rich in architectural textures. Old buildings grow by sprouting dormers or jacking up their roofs, acquiring new skins of aluminum and fake brick without completely shedding the old. On Main Street buildings are young at the bottom and old at the top. They beckon shoppers with flashy plastic and metal signs while retaining their original elegant stone facades several stories up. The mansions, once owned by silk mill barons, in the Eastside neighborhood are being restored, and former industrial buildings are being converted into market-rate condos.

The industry that grew around the Falls is long gone, but the history remains. Both nature and man played pivotal roles in Paterson's founding and living legacy. Of the many small cities with a deep connection to some of the most compelling chapters in American history, industry and social change, Paterson is not to be overlooked.

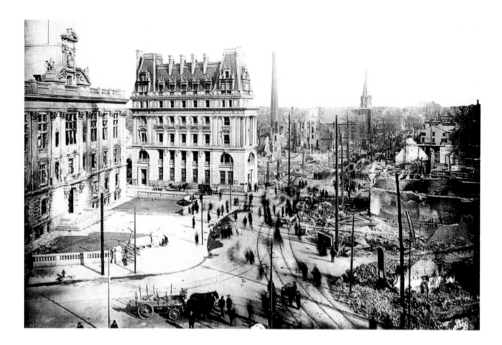

Much progress was made after the fire of 1902. Reconstruction was financed by local banks, insurance money and private donations and the wealthy paid for relief to local families. Mayor John Hinchliffe refused outside capital, wanting to show Paterson's strength that the fire was only a minor setback, and that Paterson could take care of itself.

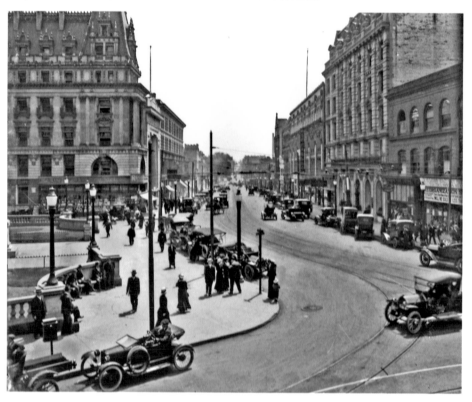

ACNOWLEDGMENTS

I never thought I would be an author or that it would be even possible to write and publish a book of my own, but here I am on my third book. I didn't do it alone and I am incredibly grateful to everyone who helped me on this latest project. I'd like to thank everyone I've ever met in my life, but there are certain people I want to specifically single out and acknowledge; so many wonderful people who came together to make this book possible.

A special thank you to Congressman Bill Pascrell, Jr. for his contribution to this project by writing the foreword to the book. Not only has Bill been in Congress since 1996, he was elected Mayor of Paterson in 1990, and elected to the New Jersey State Assembly, but most of all, he is a life-long friend.

Roberta Papale, my editor and spectacular support system for her warm encouragement, excellent advice and skillful guidance. Ann Graham, for her time and effort in providing a wealth of information, photographs and memories. Jerry Nathans, President Emeritus and Dorothy D. Greene, President of the Jewish Historical Society of North Jersey, for allowing me access to their photographs and Michael Kemezis, archivist, for scanning photos for me. Ina and Bill Harris for driving and touring the city to take photographs for the comparative photos of this book; Maryanne Christiano-Mistretta, a gifted and talented journalist, for her photo of Eastside High School.

Thank you to the Library of Congress, the New Jersey Digital Highway, American Labor Museum, the New Jersey Historical Society, Paterson Museum (Jack DeStefano, Curator and Joe Costa, Photo Archivist), the Passaic County Historical Society for all their images that appear throughout this book and Mike DeJesus and his 'I Grew Up in Paterson' Facebook site for all the wonderfully nostalgic images that appear there. I could have never done it without his help. Thank you also to Karen Kanis Pomante, Pat Kirwin Henderson, Bernard Jaz Payne and Zeke Madjar. Thank you to Tony Vancheri, former Superintendent of Parks and Shade Tree of the City of Paterson and Veterans Council President for the photos of Vietnam Veterans Park, Esther Rifkin, a friend from my Paterson Library days for her photo of Westside Park and Richard Englehardt of Grand Hardware for his photo contribution. You all made this project a reality.

CONTENTS

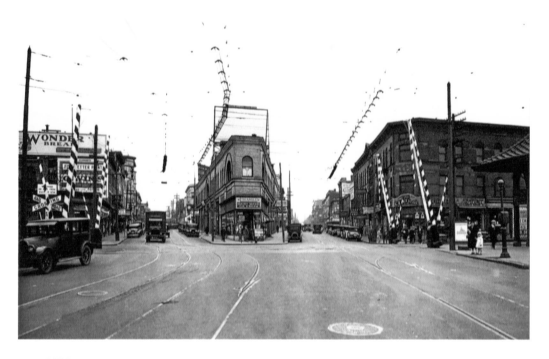

1929: A photo where Market Street and Park Avenue merge. Far right shows the overhanging roof from the Erie Railroad passenger station. Behind the station is Central Cafeteria in the former Bellevue Hotel. In the center is Central Building which occupied the entire block. The trolley lines are still visible but the last electric trolley ran in 1926.

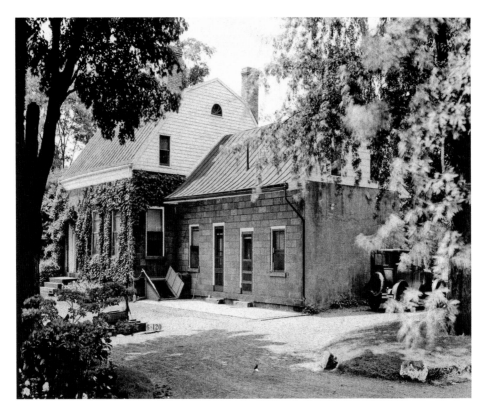

THE VAN HOUTEN HOUSE: Built in 1831, the Van Houten House was added to the National Register of Historic Places March 7, 1973. Washington visited the house in Westside Park when he was staying at Dey House in 1780. In 1870 the Van Houtens sold it to the Rossiter family and became known as the Rossiter Farm. Paterson purchased it from this family and incorporated it in Westside Park. It is the home of the Old Timers Sports Hall of Fame.

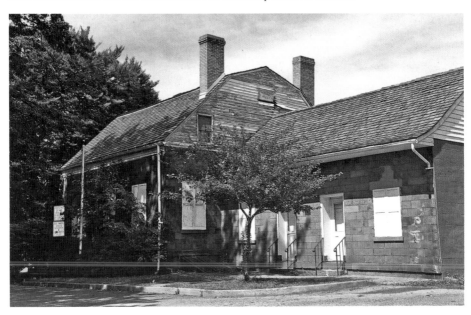

FOREWORD

Paterson began as the brainchild of Alexander Hamilton, who envisioned an industrial hub of wealth, independence and security that would inspire the nation. Over the years, this dream has drawn thousands of immigrants, forging a community rich in cultural diversity.

This city begins and ends at what lays at the heart of it: The Great Falls. There is no Paterson without the Falls. Their breathtaking and majestic beauty aside, it's the Great Falls that fueled Paterson's development into a leader of the nation's Industrial Revolution. I often return to the Falls for a moment of serenity in a bustling city, recalling the proud moment when joined by my friend, the late Senator Frank Lautenberg, we were able to successfully pass the legislation to establish the Great Falls National Historical Park in our hometown.

I was the Mayor of Paterson for seven years and have represented it in Congress for nine terms. I am a son of this great city. A lifelong resident of a place that has grown and changed yet remains as dynamic and varied as it was in Hamilton's time. The Silk City has transformed, but Paterson, New Jersey has been and always will be a reflection of American industry and prosperity.

CONGRESSMAN BILL PASCRELL, JR.
Ninth Congressional District

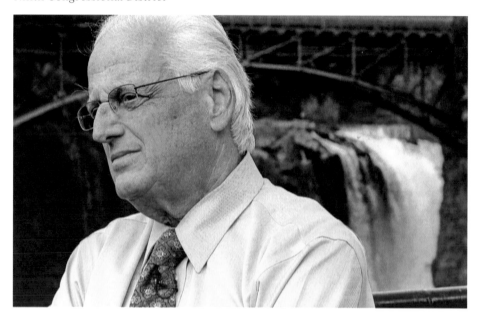

CONGRESSMAN BILL PASCRELL, JR. with the Great Falls in the background.

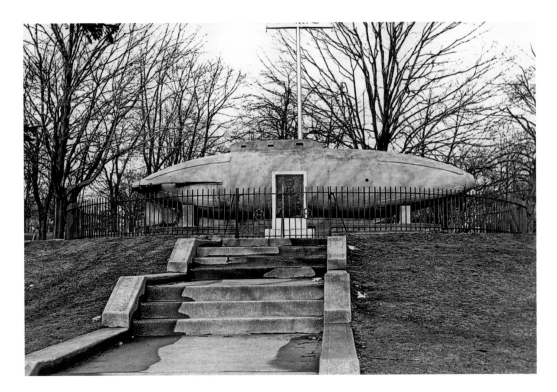

THE FIRST PRACTICAL SUBMARINE: Designed and built by John P. Holland, the submarine was launched in the Passaic River in 1878. This submarine, after being displayed in Westside Park for many years was moved indoors and on display at the Paterson Museum. Holland sold the United States Navy its first submarine in 1900.

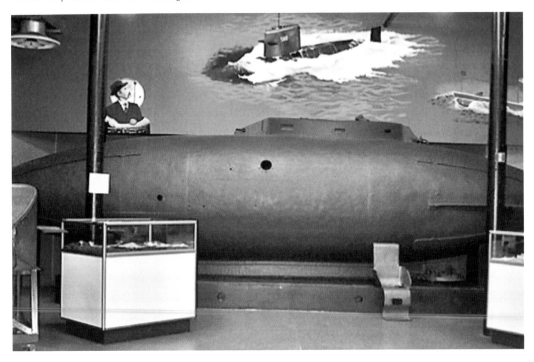

DOWNTOWN PATERSON

The Downtown commercial district was placed on the National Register of Historic Places in 1999. Not only is it where the city bustles, but it is also where some of the finest examples of architectural splendor of its day still exist. On February 18, 1902 a fire was discovered in the trolley car sheds of the Jersey City, Hoboken & Paterson Railway Company on Broadway, a few minutes after midnight. The high winds blew through the tinder-like building and it was consumed by the flames. In spite of the heroic efforts of the Fire Department, the flames devastated most of the business center of the city. When the fire had finally burned out, it had been considered the largest in the city and the greatest fire in New Jersey and the United States. Demands to re-build by the people of Paterson showed determination and strength, using the wealth of the City's prosperous industrial industry. The majority of the buildings in the downtown area were constructed within twenty years of the fire. Suburban expansion and the advent of grand malls in nearby Wayne and Paramus have lured shoppers away from downtown Paterson. The Great Falls is now a national park rather than a source of power, but commerce is still an integral part of the city's identity. Small businesses have replaced big-name stores.

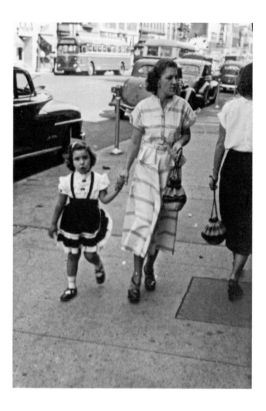

The Author and her mother in 1949 in downtown Paterson.

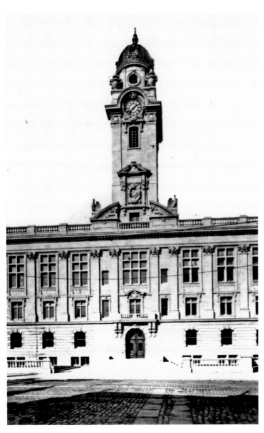

July 6, 1896:

On July 6, 1896, city elders and politicians met on Market Street to dedicate the new City Hall. It was a five-year enterprise that on that day evoked great community pride for a city grappling with its identity. During the 1896 dedication, the tower and illuminated clock faces would be a magnet to draw residents to City Hall. In 2008, the copper dome on top of the tower's cupola was replaced and the clock system repaired so that the bell would toll on the hour; a new lighting system illuminates each of the four clock faces.

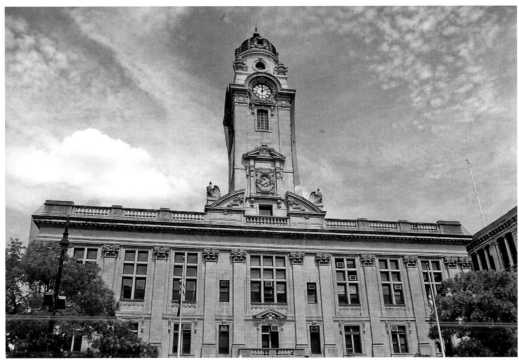

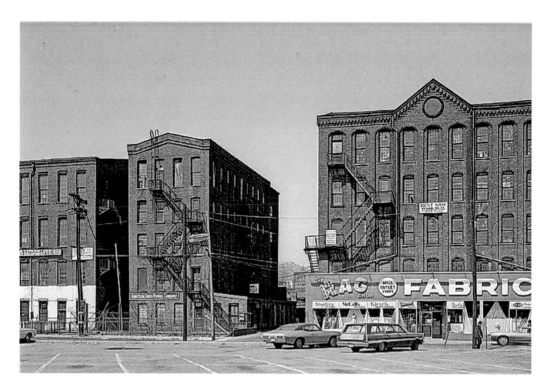

JUNE 26, 1992: On June 26, 1992, City officials, along with the Lou Costello Memorial Association created Lou Costello Memorial Park. It was a tribute to the famous comedian from Paterson. Titled 'Lou's On First', a life-size bronze statue of Costello, wearing his trademark Derby, dressed in a business suit, and holding a bat over his shoulder, as if performing his routine 'Who's on First', was unveiled at the corner of Cianci and Ellison Streets, a former parking lot used by the City of Paterson for city employees.

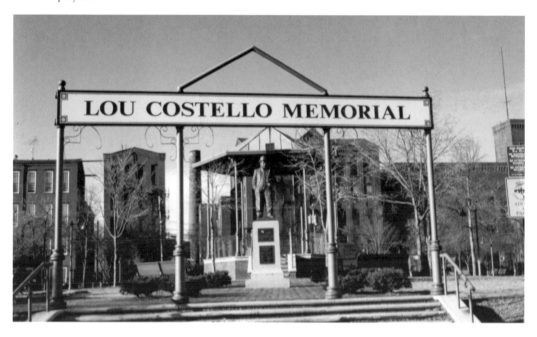

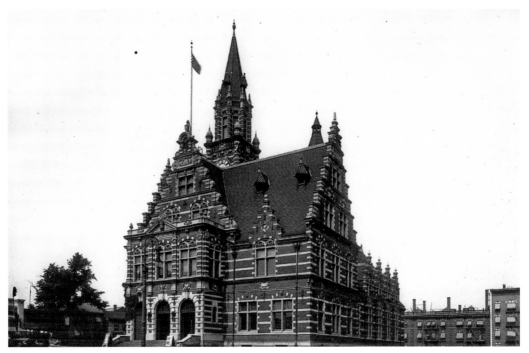

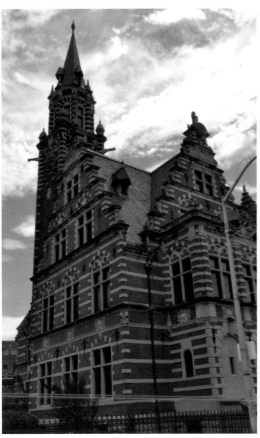

THE 1899 FLEMISH STYLE BUILDING: This may have been based on buildings constructed in the Haarlem Market in the Netherlands and the first major federal building in Paterson and helped form the civic center of the city. The brick and stone building includes stepped gables, stone tracery, a decorative tower and steeply pitched clay tiled roofs. It continued to house the post office until 1932 when the county acquired it and in 1937 was re-dedicated as the Passaic County Administration Building and continues to serve the public as a courthouse and administrative offices.

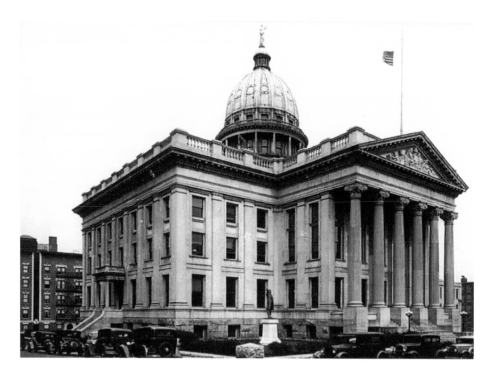

APRIL 27, 1898: The cornerstone of the new courthouse was laid on April 27, 1898, but due to entanglements and delays in construction, the building was not ready for occupancy until November 1903. Prior to the construction of a formal courthouse, the first court was held at the house of Ira Munn, and then the basement of the Passaic Hotel. Today the courthouse has expanded to several buildings, with over 600 employees and 30 presiding judges. On any given day, the complex may have more than 3,000 people within its confines – a far cry from their humble basement beginnings.

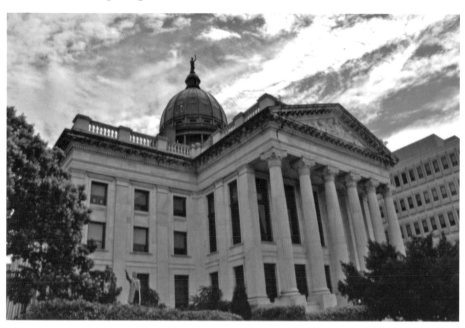

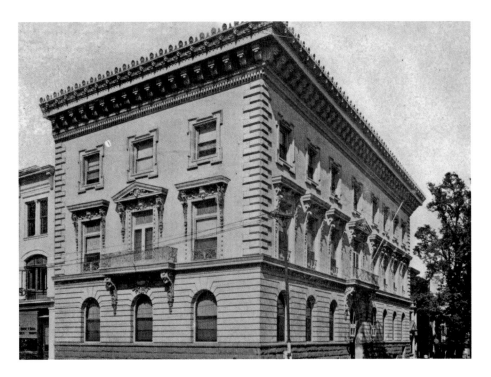

THE HAMILTON CLUB: The Club, modeled after the Palazzo Medici in Florence, Italy, opened in 1897, as an exclusive gentleman's club. Garret A. Hobart, Vice-President under McKinley in 1896, was a Paterson attorney at the time, and one of the founding members. Completely gutted by the fire of 1902, the club was re-built and re-opened to its members the following year. Currently it houses the Passaic County Cultural and Heritage Council and the Poetry Center at the Passaic County Community College and an art gallery of contemporary art for its permanent collection.

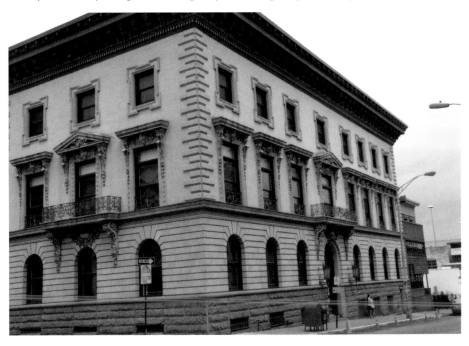

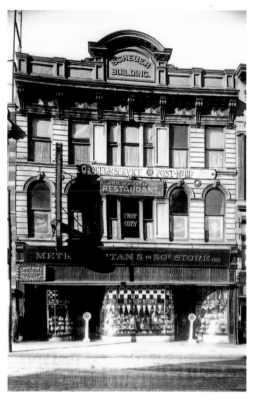

SCHEUER BUILDING:

The Scheuer Building on Main Street was a Newark-based chain of grocery stores founded in 1860. In 1887 Scheuer opened his first Paterson branch and entered into partnership with Nathan Fleischer which lasted until 1898. It became the largest retail grocery store in New Jersey. The building still stands on Main Street. You can recognize it from the second floor up. The bottom floor was always a 5&10 such as Kresge's 5&10 and now is C. H. Martin. A Chinese restaurant was on the upper floor where a 'For Rent' sign now appears in the windows.

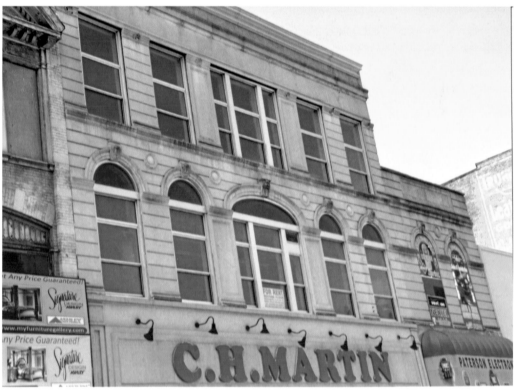

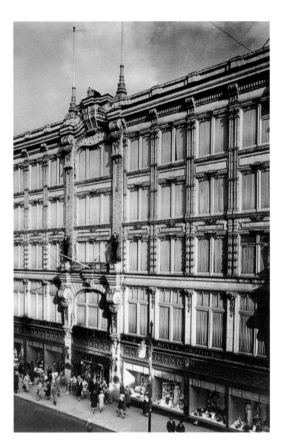

MEYER BROTHERS:

Meyer Brothers was a family-owned and managed store and was the department store synonymous with Paterson. It had been an institution since the 1880s. It was a classy store with brass-gated elevators; the elevator operators sat on fold-up seats; bells dinged when they were in use, and red and green lights indicated whether they were going up or down. The store had a wonderful smell. The mezzanine had a bookstore with books in wood bookcases and a restaurant. Destroyed by fire in 1991 they eventually moved to Wayne, New Jersey but went out of business in 1995. A mall was built in place of the buildings lost.

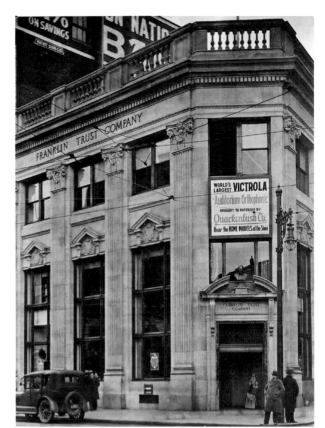

FRANKLIN TRUST COMPANY:
The Franklin Trust Company has a bronze bust of Benjamin Franklin sculpted by Gaetano Federici in the pediment of the building over the main door. The Franklin Trust Company was a key building in Paterson's financial district. It is located directly across from City Hall on Market and Hamilton Streets. Now Chase Bank occupies the building.

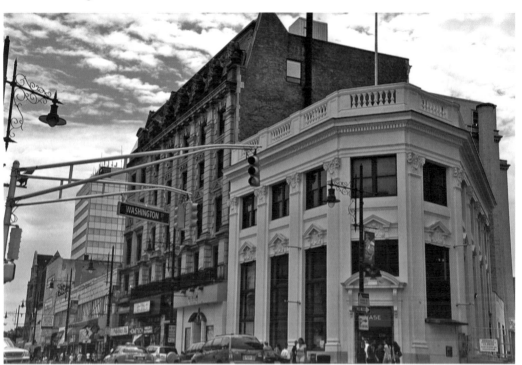

ALEXANDER HAMILTON HOTEL:
The Hotel was built in 1930 and named for the first United States Treasury secretary. This swanky, handsome eight-story building, with 170 rooms was located two blocks from City Hall and surrounded by Lankering Cigar Store and a hat shop, plus the Fabian Theatre. It included an elite men's club, and a Luxor bath in the basement that was a gathering place for some of Paterson's most powerful men. As the city declined in the 1960s, so did the hotel, until it fell into disrepair.

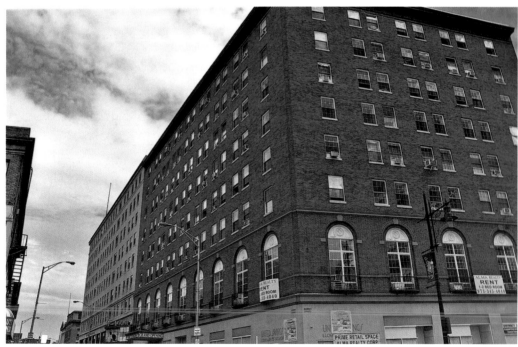

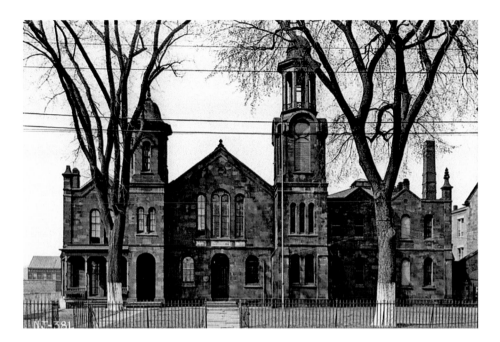

THE JAIL AND SHERIFF'S HOUSE: This photo of the original site of the jail and sheriff's house taken in 1938, was on Main Street. Frank Davenport, Sr. was elected sheriff in 1930 and served until 1944. Prior to that he was head jailer at the county jail from 1894 until 1922 and was the last jailer to ring the 'Hanging Bell' in 1904. Passaic County executed five men convicted of murder between 1850 and 1904. He was also the sheriff when the bell was dismantled in 1938. Frank Jr., his oldest son, became the sheriff in 1960 to 1974 and was later elected State Senator. The new, modern jail stands at 11 Marshall Street instead of its original site.

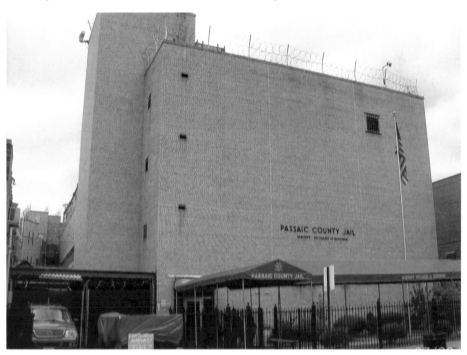

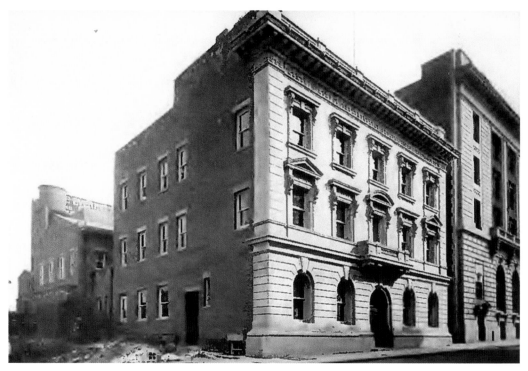

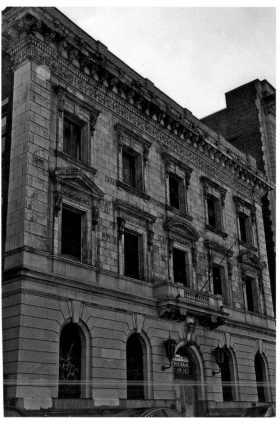

PATERSON POLICE DEPARTMENT:
The Department was burned out
of its ornate, turn-of-the century
headquarters on Washington Street on
February 8, 1980. The building stands
vacant today, its windows are boarded
up and the regal lanterns frame the
'For Sale' sign that hangs at its once
grand entrance. Its ornate façade
is weathered and hides a damaged
interior as well as a forgotten story.
Eventually they moved to the Public
Safety Complex on Broadway.

YMCA:

The YMCA is located at Ward Street (now called Federal Plaza) and Prince Street in the downtown area of Paterson. After the 1997 expansion of the Y, there were 210 residential rooms. A new resident door was added to separate youth programs and athletics. In the early days goldfish were put in the pool as an incentive for those learning to swim. The building still looks the same today. The only difference is the cars and utility poles and the house across the street no longer looks the same.

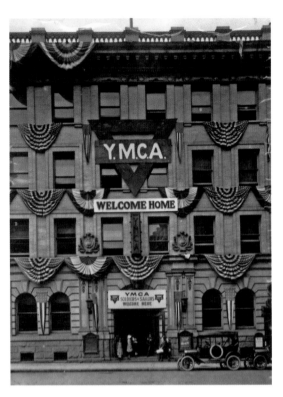

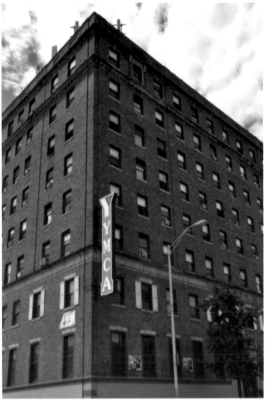

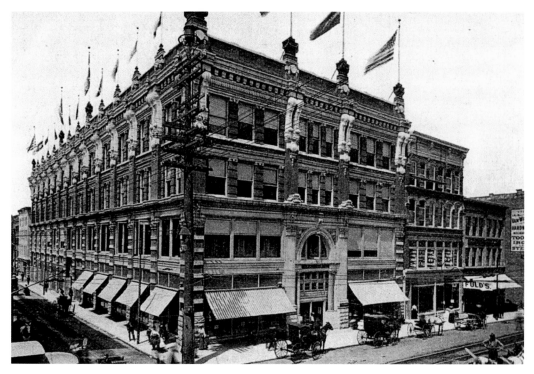

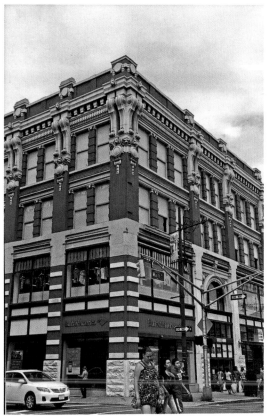

QUACKENBUSH DEPARTMENT STORE: Quackenbush, or 'Quacks' as it was known, offered quality goods for decades and had a toy department on the first floor with cartoon viewing machines for the kids. There was a spacious staircase on the first floor of the store where schools would vie for that spot to hold Christmas concerts during the holidays. Sterns took it over, then Jacobs, now it is a Bank of America and various other shops.

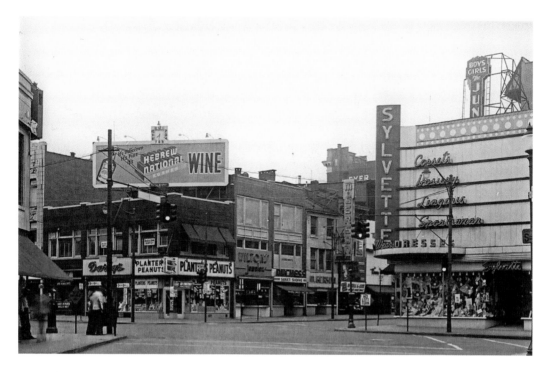

'DOWNTOWN PATERSON HAS EVERYTHING': They used to say that 'Downtown Paterson has everything'. I can remember the smell of roasting peanuts coming from the Planters' Peanut Store on the corner of Main Street and Broadway. A costumed Mr. Peanut Man would walk up and down, outside the store, handing out hot, freshly roasted peanuts to passers-by. I had collected Mr. Peanut whistles, pencils and ink blotters. A fire in the 1970s closed the 121 Main Street store for good. Broadway Pizza is at Main and Broadway now.

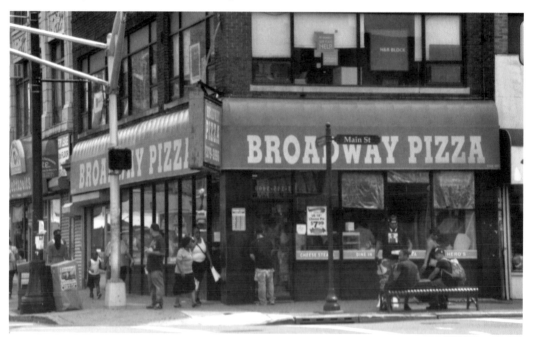

CENTRAL FIRE STATION:
The Central Fire Station at 115 Van Houten Street opened on March 19, 1912 as the headquarters of Engine Co. 1 and Engine Co. 5. Later that year Truck Co. 2 moved in. In 1982 it was replaced by the Madison Avenue station on the former site of the Paterson General Hospital. Greenbaums Interiors uses it as a warehouse now for their furniture.

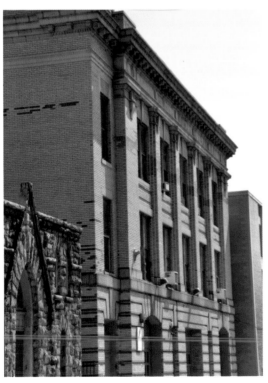

NEIGHBORHOODS

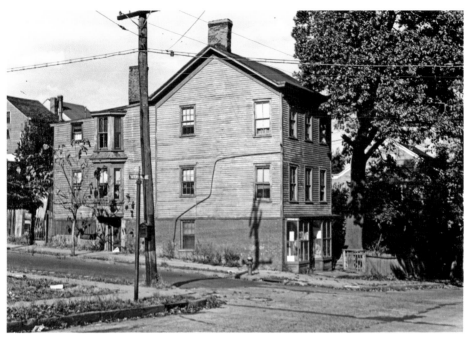

MY PARENTS' HOUSE:

When my paternal grandparents came to the United States in the early 1900s, they purchased a house on the corner of Paterson Avenue and Front Street in the Totowa section of the city. There was a store that faced Front Street that my grandmother owned as a confectionery store which my uncle later used as a television repair shop. In the 1950s, my parents purchased the lots which were next door from my grandmother for $500 and built a house on the property. My parents lived in that house until 2007, the year both passed away.

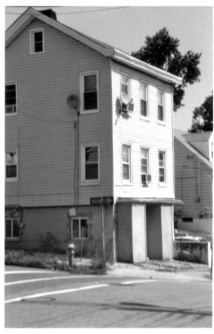

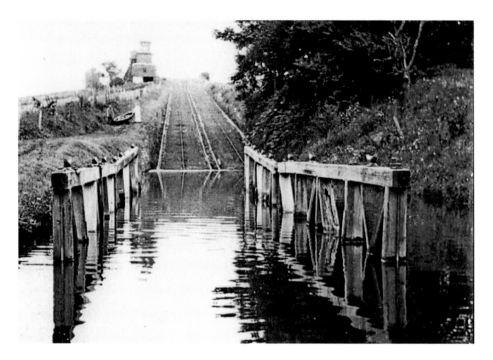

THE MORRIS CANAL: The 107-mile man-made Morris Canal ran across northern New Jersey from the late 1820s to the 1920s. It was different from other canals as it defied terrain, literally climbing hills and mountains by way of locks and inclined planes climbing a total of 1,674 feet of elevation change. It was the only means of shipping in those days. In Paterson it ran through where Route 19 now exists. With the advent of the railroad, the canal began to become obsolete. The state of New Jersey took it over in 1922 but was formally abandoned in 1924. The only remnants of the canal's existence are signs that are posted along its route.

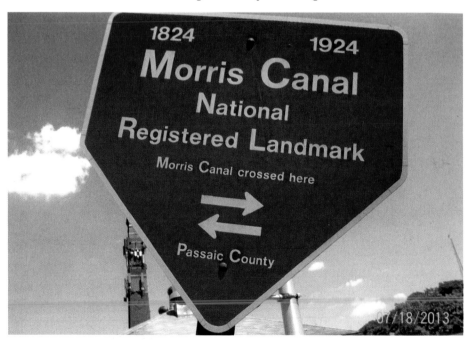

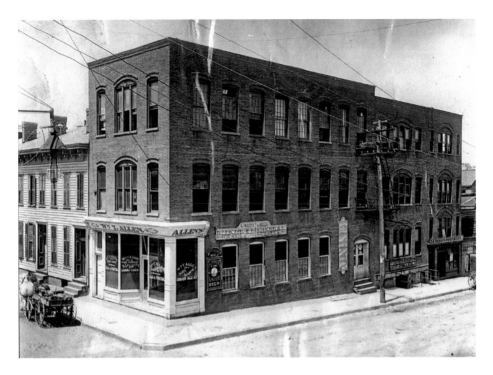

HUNTOON-VAN RENSALIER UNDERGROUND RAILROAD: The Railroad is at the intersection of Broadway, Bridge Street and Memorial Drive. Josiah P. Huntoon, a white businessman and William Van Rensalier, a black engineer, whom Huntoon employed, were both conductors of the Underground Railroad from 1855 to 1864. Today the spot is marked by a sign on the piece of land between the Public Safety Complex and a Wendy's. It was declared a Municipal Historic Site in the 1990s since Paterson was a 'station' on the Underground Railroad.

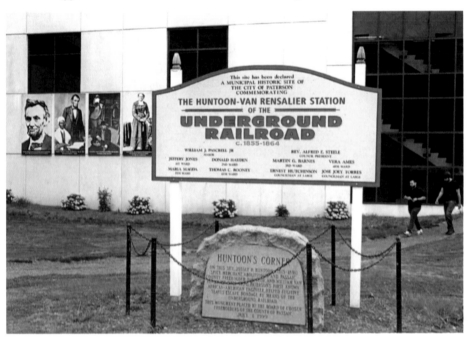

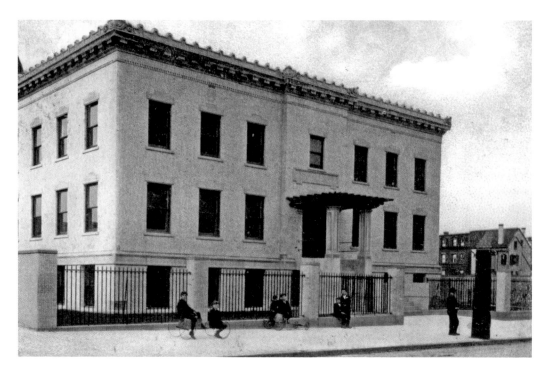

MEMORIAL DAY NURSERY: The Nursery began operating in 1887 on Straight Street. It slowly outgrew this location and is still operating 125 years later at Grand Street. In its first year of operation the day care facility served sixty-two children. Originally called 'The Nickel House', in the late nineteenth century the charge for the care of one child per day was five cents. On June 25, 2013 the City Council named this location a city historic site.

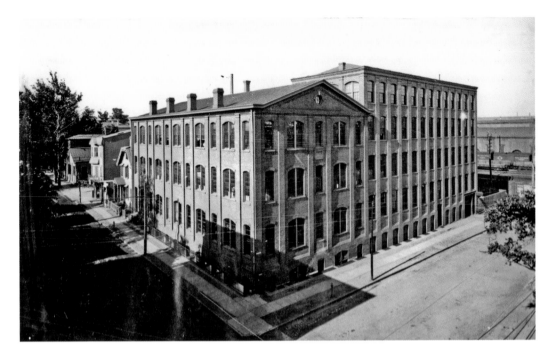

JOHN ROYLE & SONS MACHINE WORKS: The machine works was erected in 1888 on Essex and Straight Streets. The old factory, with its period-look exterior, represented the legacy of a family that was well known in nineteenth-century Paterson. In addition to the textiles, rubber tubes and insulation for wires their machines made, several pieces are preserved in the Smithsonian. In spite of this century old mill being eligible for listing as a national landmark, the owners decided to have the building demolished.

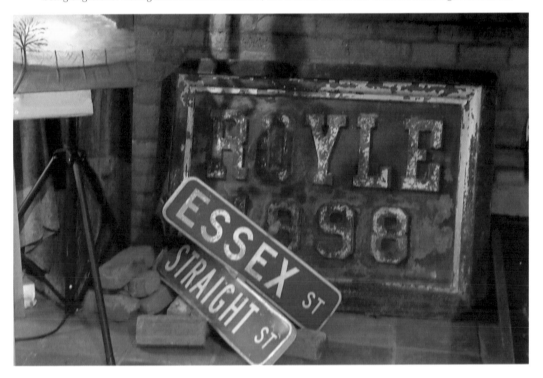

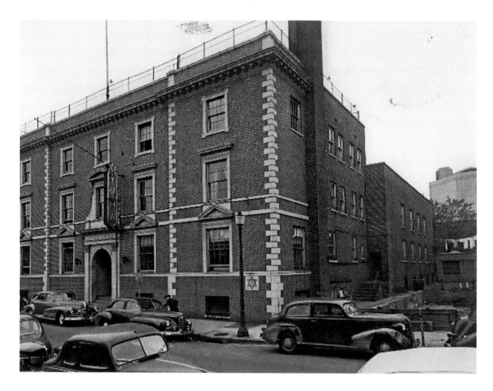

THE ORIGINAL SITE OF THE YMHA: The original YMCA was located at Broadway and Carroll Street in the Orpheus Hall building. Fred Wesley Wentworth designed a building that had its ground breaking on November 8, 1923 on Van Houten Street. It included social halls, a swimming pool, classrooms and meeting rooms. It eventually closed in Paterson and moved to a location in Wayne in 1976.

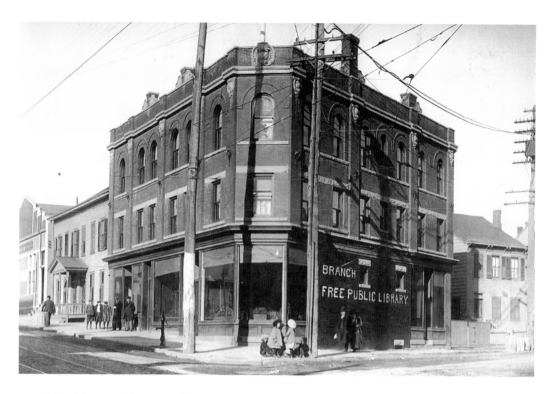

THE TOTOWA BRANCH LIBRARY: The Library was originally on the corner of Hamburg (now West Broadway) and Belmont Avenues. The house to the right is still there. In the 1950s it was a drug store. There is now a Checker's fast food restaurant on that spot. The library branch moved to Union Avenue in 1941 in a former converted bank building. The library was a sanctuary for many of the neighborhood kids and I was one of them.

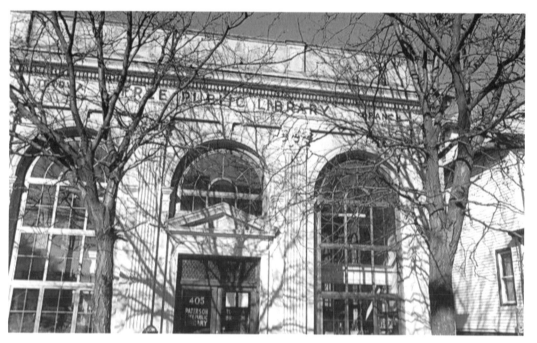

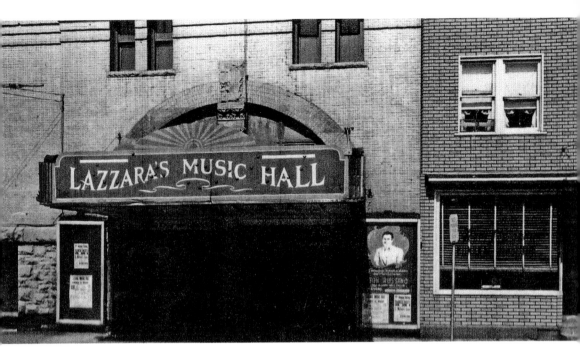

LAZZARA'S MUSIC HALL: Lazzara's was originally a Swiss and German Music Hall on Cross Street. The street was later re-named for Monsignor Carlo Cianci who became pastor of St Michael's Roman Catholic Church in 1919. Cosmo Lazzara opened Lazzara's Music Hall in the early 1900s and in the 1930s it featured a dance hall, live Italian 'soap operas', stage plays, boxing, wrestling, noted Italian singers and it showed Italian movies. Lazzara was also known for his successful bakery on Cross Street. The site is now a parking lot.

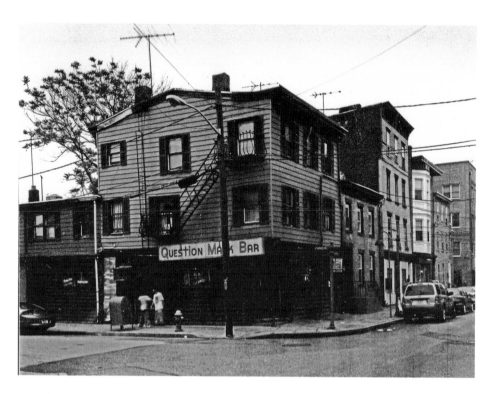

THE CORNER OF VAN HOUTEN AND CIANCI STREETS: At the corner sits the renovated Question Mark Bar. A century ago it was called the Nag's Head. The Question Mark Bar, a working-class tavern, had its own important role in Paterson's history. It is the place where Irish and Italian laborers flocked when all the mills were alive. Paterson's radical mill workers made it their headquarters and the bar was the spiritual center of the great silk strike of 1913.

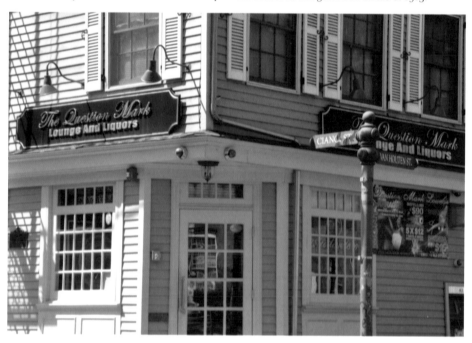

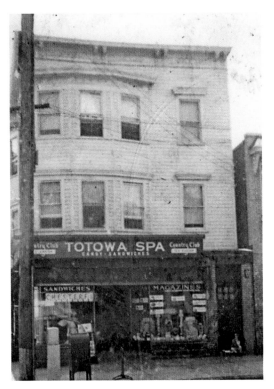

The Totowa Spa:

The Spa was on the corner of Union and Wayne Avenues in the Totowa section of Paterson. It was a favorite spot for teenagers before and after school for ice cream and sodas. We played the jukebox and no one was in a hurry to make you leave the premises. Across the street there was another favorite teenage hangout called Netzer's. Now it's a Spanish restaurant.

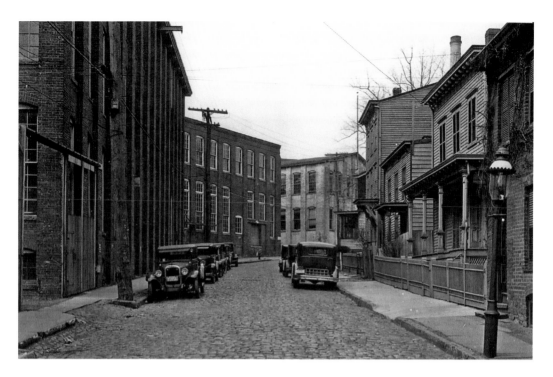

THE ADDY-VENABLE COMPANY ON RYLE AVENUE: The Company is on the left looking up to the National Silk Dyeing Company at the top of the street. A row of workers' housing stands in the shadows of the factories across the street. Most of the same houses are standing today. On July 16, 2013, the mill that has been vacant for over a decade, has been demolished after an entire wall of the building tumbled to the ground, blocking traffic, and knocking down power lines.

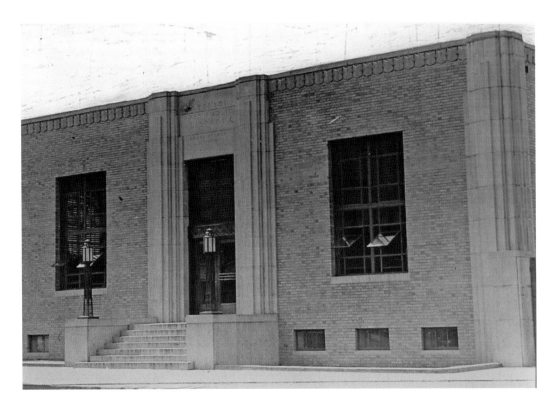

GRAND STREET BRANCH LIBRARY: The Library was the crowning achievement of Board President William Blauvelt. He dedicated a great deal of time to secure the funding needed to erect this art-deco style building. Sadly, before the building was complete, he passed away. The building was razed in the 1990s to make way for the Passaic County Jail expansion and parking lot.

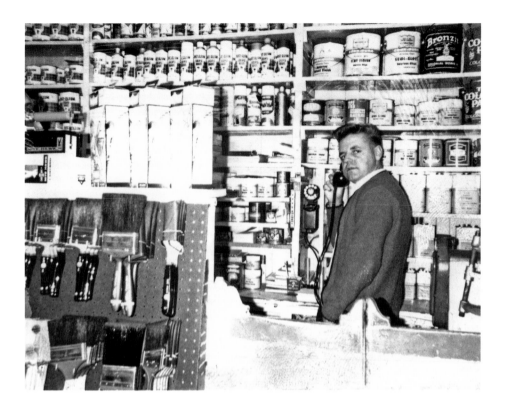

GRAND HARDWARE: Grand Hardware was established in 1895 on Grand Street by the Neil family. Originally called T. G. Neil Hardware it was across the street from the site where Grand Hardware now stands. The original building was demolished to make way for a parking lot. Purchased in 1956 by former sheriff Ed Englehardt (pictured) it was managed by his brother Dick and eleven years ago, Richard, Dick's son, took over the business.

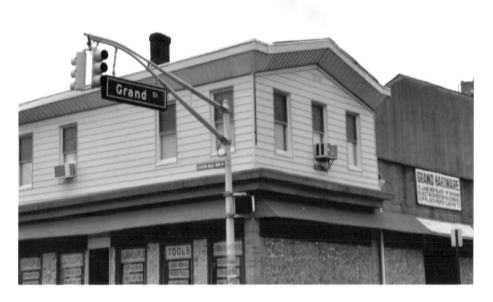

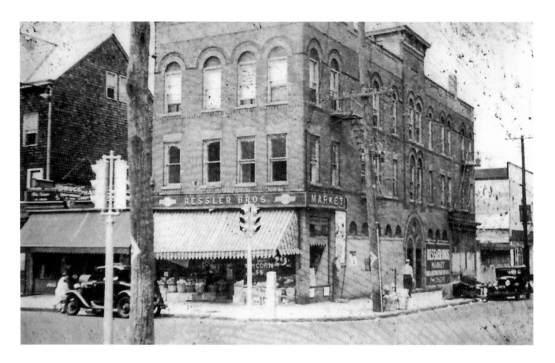

THE CORNER OF WAYNE AND TOTOWA AVENUES: The corner is a popular intersection of the Totowa section of the city. Valerio's Pharmacy was next door and The Red Bar restaurant was on the opposite corner. It had always been a local grocery store for the residents of the neighborhood. Living only five blocks away from this market, I frequented it often when it was Lou's Market, owned by Lou and Esther Territo, then Benvenuti's and now it is El Nuevo Bodegon.

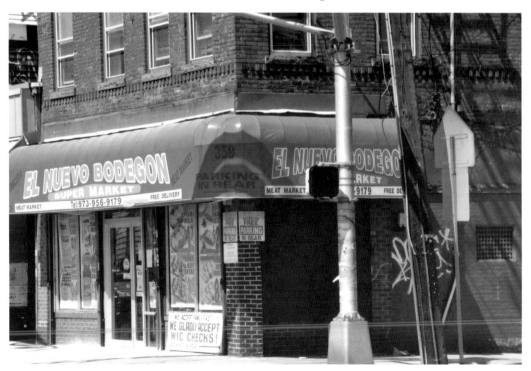

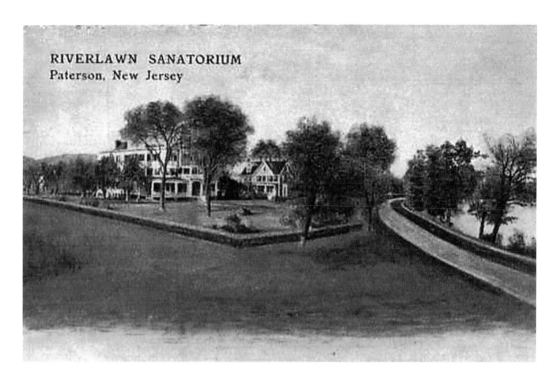

RIVERLAWN SANATORIUM
Paterson, New Jersey

RIVER LAWN SANATORIUM: The Sanatorium was a high-class private institution for mental and nervous disorders. The three-story brick and frame building that was located at 45 Totowa Avenue was owned by Dr D. T. Millspaugh, and considered to be on the 'outskirts' of the city. Famous Irish playwright, Eugene O' Neill's brother Jamie was a patient there for alcoholism and subsequently died there. In January 1903, the sanitarium was destroyed by fire. All the patients, approximately thirty, escaped without injury. In 1997 I purchased the home deeded at 45-47 Totowa Avenue and lived there until 2007.

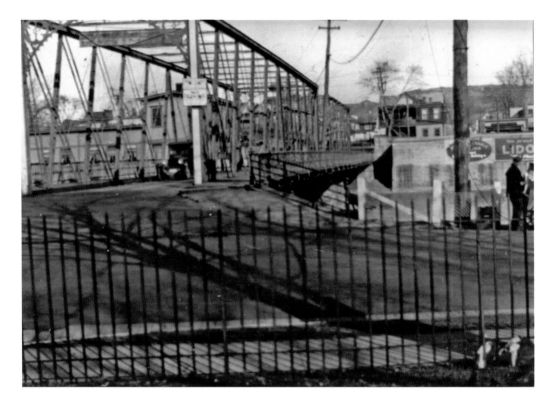

LIDO VENICE: The Lido Venice was a flamboyant nightclub run by three brothers, Nicholas, Joseph and Michael Durandy who bought the venue from another brother in 1927. Located on a small island midway across the Passaic River, the only access was from rowboats. Lido Venice had a variety of names but with most of its history faded it is known only as Block 5012, Lot 1. Purchased by the county in 1962 from John and Jessie Watters, there is only a concrete slab overgrown with trees and brush left that is visible from the bridge.

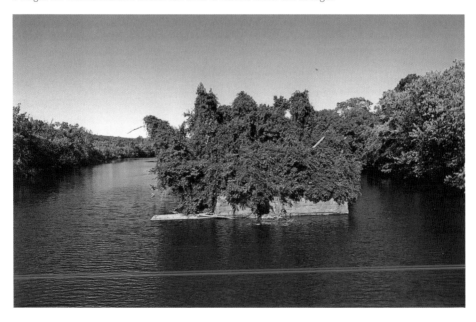

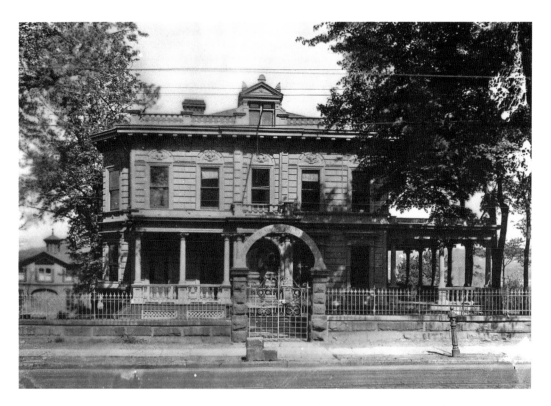

DAUGHTERS OF MIRIAM:

The Daughters of Miriam's original site and humble beginnings were at 469 River Street, grounds that were purchased by Nathan Barnert and deeded to the Daughters of Miriam on November 1, 1920. It evolved from a 'Home for the Aged and Orphans' through a 'Home and Infirmary for the Aged' to its ultimate expansion and transformation into a 'Center for the Aged', now located on Hazel Street in Clifton, New Jersey.

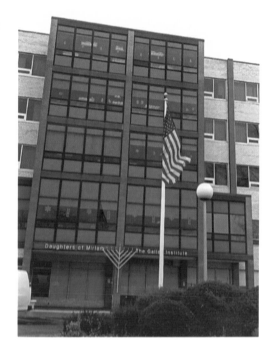

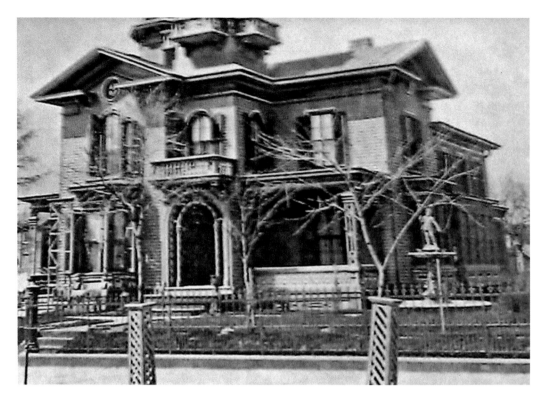

ROBERT HAMIL'S RESIDENCE: The residence was on the northwest corner of Broadway and Summer Street. Hamil was one of Paterson's famous silk pioneers. The names of Hamil and Booth left their stamp in the annals of Paterson's great industrial history. Their looms produced a black silk dress for Mrs James A. Garfield during her period of bereavement. She was not the first nor the last First Lady to wear fabrics made from Paterson's looms. Hamil's residence was situated across the street from the Danforth Memorial Library but it has been replaced by a large BP gas station.

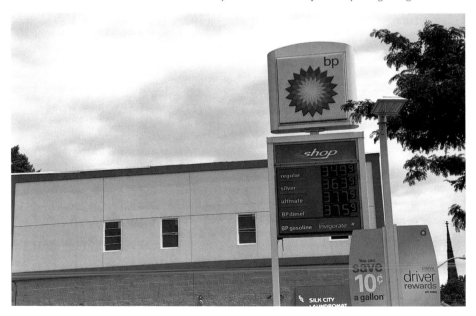

CHAPTER THREE

PATERSON'S PARKS

Let the bell ring! It ushers the dawn of a
new era for Paterson. With parks will come
better streets, better ideas, more progress
and a better city for us all to live and
work for. One advanced idea develops others,
and the effect of this onward step will be
felt in every hand in the future. I feel
amply rewarded for all my labor in having
at last succeeded in getting parks an accomplished
fact. I am unselfish in this matter, for I do
not expect to live long enough to reap much
benefit personally, but I think it is the
highest wisdom for us today to secure these
blessings for those who are to come after us.
Our children's children, will live to see Paterson
A city whose population will run into the
hundreds of thousands and who will appreciate
what has been secured for them tonight.

These are the words of Henry B. Crosby, 'Father
of the Parks' who served on the first Park
Commission in Paterson in 1889. Because of his
enthusiasm, he had the First Baptist Church bell
ring in honor of the first public park.

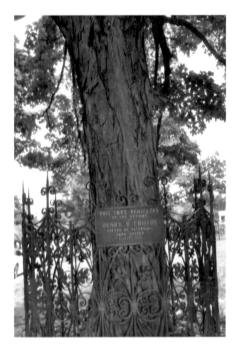

EASTSIDE PARK:
A tree was planted in Eastside Park in honor of
Henry B. Crosby, Father of the Parks. A wrought
iron fence surrounds a tree that was planted
in Eastside Park in 1894 that is dedicated to the
memory of Crosby.

EASTSIDE PARK: The Park was constructed at the turn of the century. The Derrom Mansion still stood, and there was a small lake adjacent to the river with boats and boat houses. By 1915, the mansion had been demolished and the lake filled in. New construction saw a clubhouse, ladies' comfort station, bandstand, stable, deer paddock which was removed in the late sixties, and more. It was rumored that a UFO landed in the park, but no one actually saw it. The grass was scorched where it supposedly landed in the early 1960s. Despite its numerous changes, the park retains much of its original design. The Eastside Neighborhood Association has made dramatic efforts to restore some of the historic structures and landscape elements to the park.

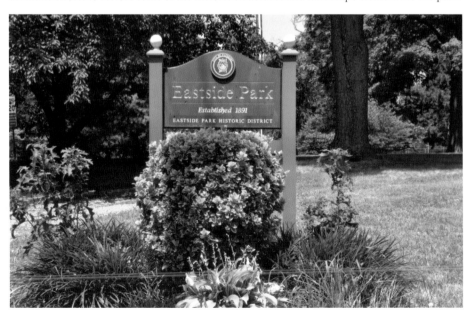

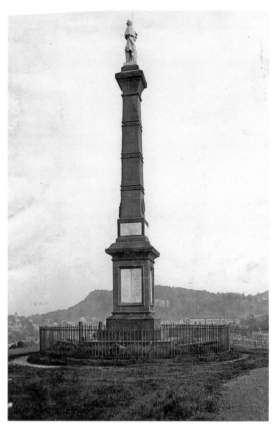

THE GREAT FALLS:

The area around the Great Falls and the stadium above the Valley of the Rocks was known as Manchester Heights and then changed to Monument Heights in the 1870s after a monument was erected honoring Paterson's Civil War Veterans. When the monument was taken down, it was disassembled and a new Civil War monument was built in Eastside Park. The statue is that of Paterson native Capt. Hugh Irish, who was killed at the Battle of Antietam in 1862. The original granite plaques with the names of Paterson's Civil War dead were re-made in bronze for the new monument and now lay in Laurel Grove Cemetery in Totowa Borough, New Jersey.

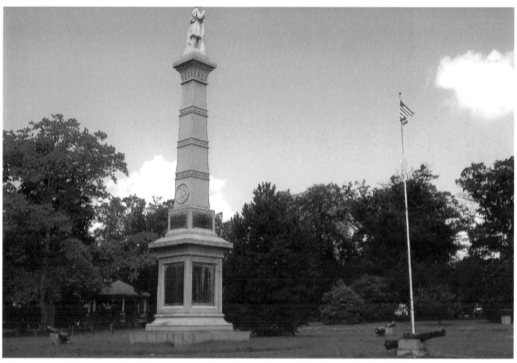

WESTSIDE PARK: Westside Park was originally called Lincoln Park with a tract of 30 acres and a cost to the city of $30,000. In 1912, the Van Houten tract was added and officially it became known as Westside Park. It was a great place for fishing for years but it is probably best known for displaying the Holland Submarine, now on display in the Paterson Museum. Kennedy High School occupies a large portion of the park on Preakness and Totowa Avenues.

PENNINGTON PARK: The Park consists of over 30 acres bordering the southern banks of the Passaic River. The City bought the park for $32,000. It was developed around 1915 with bathhouses, rest rooms and a large pavilion. By the fall of 2013, three new soccer fields will be created and three baseball fields will be renovated, including one that will be converted to artificial turf. Its convenient location by the river is an ideal spot for fishing and the pavilion is still standing.

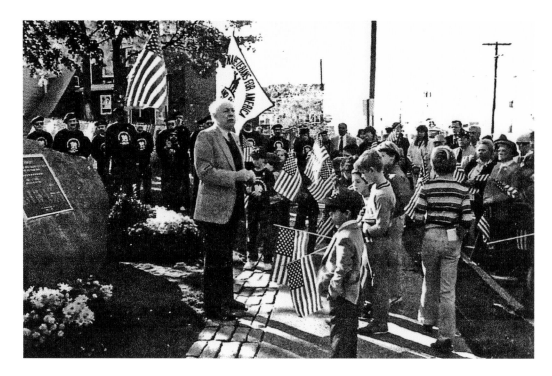

VIETNAM VETERANS MEMORIAL PARK: In 1985 Mayor Frank X. Graves Jr. dedicated a park on Union Avenue between Paterson and Manchester Avenues to the thirty-three Patersonians who lost their lives in the Vietnam War. Paterson Veterans Council President, Tony Vancheri, and his group, along with Mike DeJesus, commemorated the twenty-eighth anniversary on May 7, 2013 with a $17,000 refurbishment for the Park.

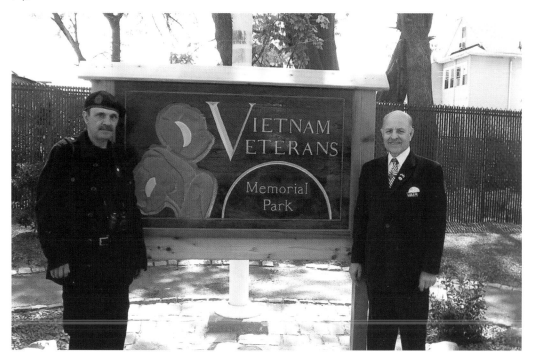

HAYDEN HEIGHTS:
Paterson Veterans show off a sign re-
naming a portion of Pennington Park,
Veterans Memorial Park at Hayden
Heights, Hill of Hero, honoring city
residents who were killed in the line
of duty while serving in the military.
Adopted by the Paterson Veterans'
Council, the park features monuments
to Paterson natives who served in the
First World War, the Second World
War, Korea and Vietnam as well as
monuments to Paterson's women
veterans, Iraq, and Afghanistan. Hayden
Heights honors William Hayden, a First
World War doughboy.

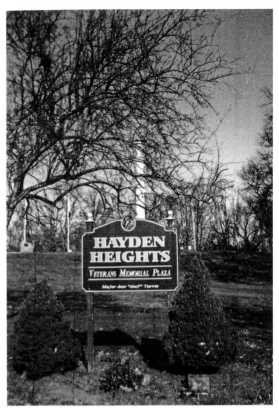

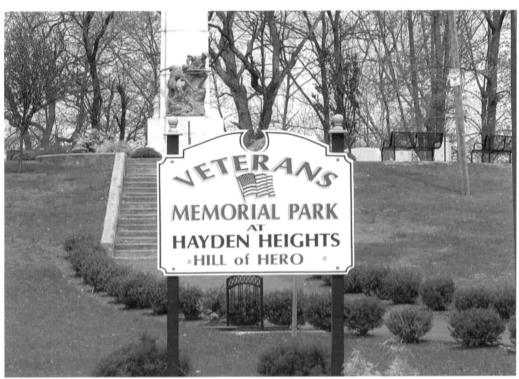

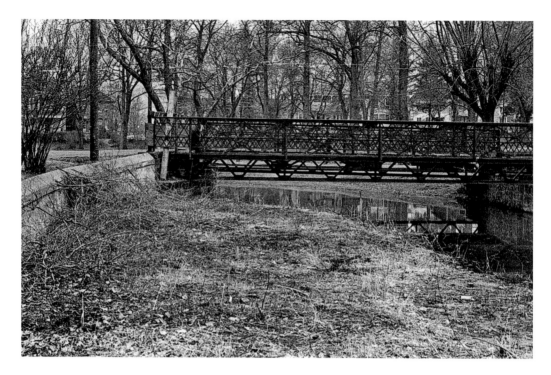

MOLLY ANN'S BROOK: The brook passes through Paterson in addition to several neighboring towns. This bridge is at the mouth of the brook and got its name from the ninth child of Dirck and Molly Van Houten, by calling himself Molly's Yawn or Molly's son. The brook ran through their property becoming known as Molly Yawn's Brook and eventually Molly Ann's Brook. The original bridge allowed cars to drive over it into the park. It became unsafe over the years and a new pedestrian footbridge was built several years ago.

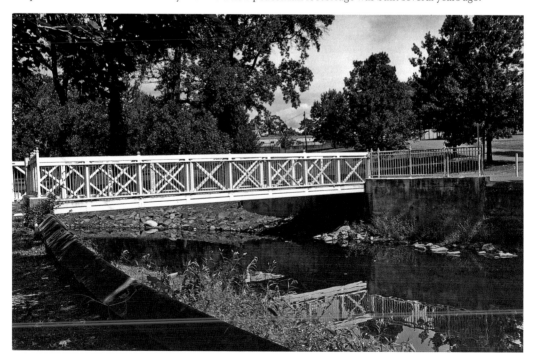

SCHOOLS

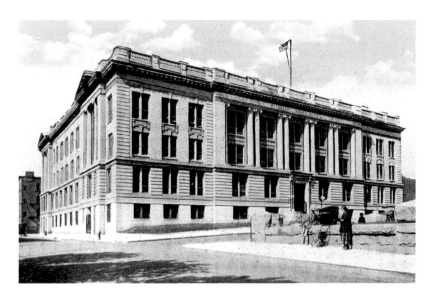

CENTRAL HIGH SCHOOL: The School, originally called Paterson High School was started in 1909. Students attended not only from Paterson, but also from Hawthorne, Totowa, Little Falls, West Paterson and Pompton Lakes. In 1921, enrollment totaled 7,000. When Eastside High School opened in 1925, it was re-named Central. After Kennedy High School was built, it was re-named for Martin Luther King, Jr. until that school was built and the building was sold to the county who now uses it as the Department of Social Services.

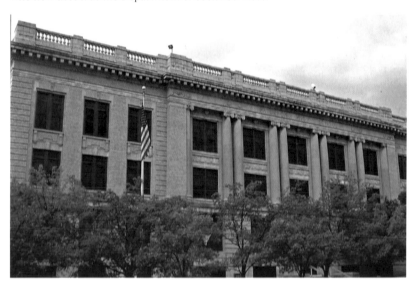

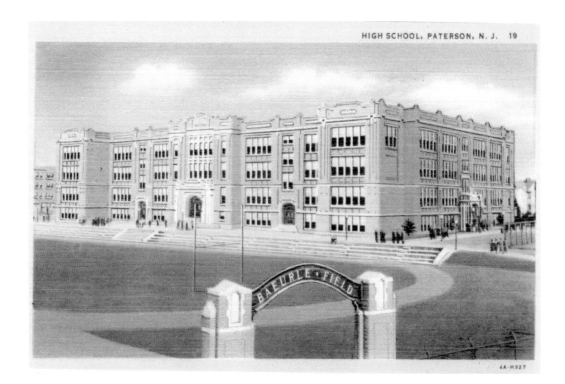

EASTSIDE HIGH SCHOOL: Eastside High School opened on February 1, 1926, and is unique in that it was built over a cemetery, making its mascot the Ghost. It is famous for its renaissance in the mid-1980s under the leadership of Joe Clark as principal. The school was depicted in the 1989 film *Lean on Me*, starring Morgan Freeman.

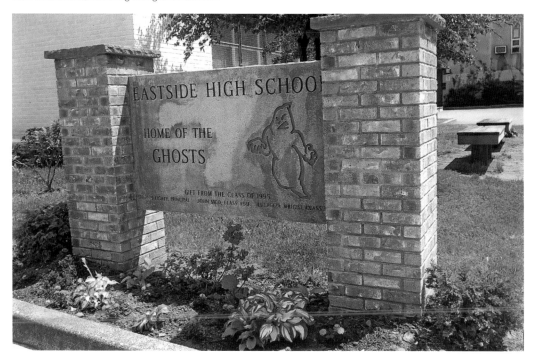

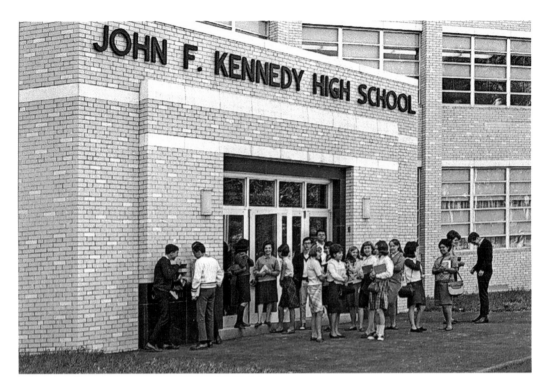

KENNEDY HIGH SCHOOL: The School was built in the early 1960s in a part of Westside Park that faces Preakness and Totowa Avenues. Originally to be called Westside High School, it was re-dedicated and named John F. Kennedy High School after the assassination of President Kennedy. In 2011 the school's theme was changed with the addition of four smaller academies operating within the high school and is now called John F. Kennedy Educational Complex.

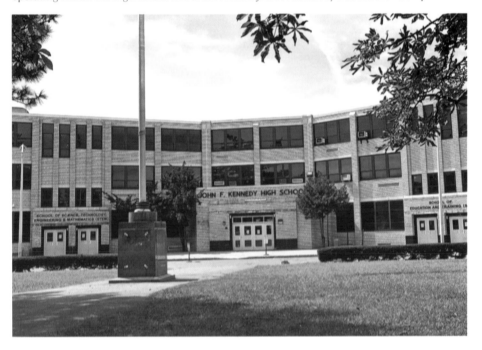

PUBLIC SCHOOL NUMBER 2: This school on the corner of Mill and Passaic Streets is a fine example of Victorian Gothic architecture. It is also significant because it was one of two elementary schools that served the immigrant Irish, German and Scotch population of Paterson's Dublin area during the last quarter of the nineteenth century. The building was converted as the city's Board of Health during the early twentieth century. The new school was built behind the old school and the building now remains vacant.

CHURCHES AND SYNAGOGUES

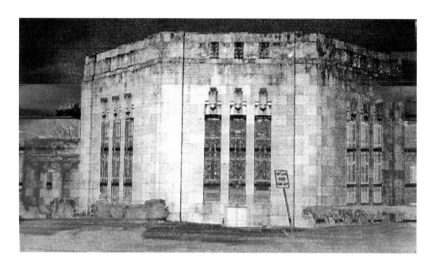

TEMPLE EMANUEL: Located at Broadway and East 33rd Street in the Eastside section, the Temple is the grandest, most architecturally significant building that Fred W. Wentworth designed for the Jewish community. The octagonal temple took synagogue design beyond what had existed in Paterson and mirrored the appearance of Chicago's Isaiah Temple. It was more than a house of worship with a school building, complete social hall and an office center. The congregation voted to leave Paterson in 1995 for a new location in Franklin Lakes and now remains vacant.

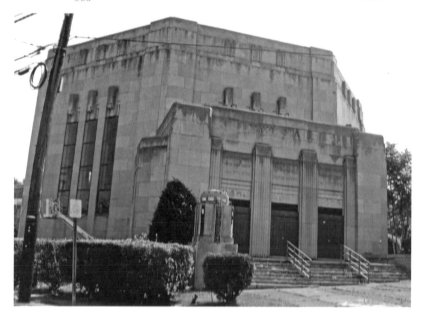

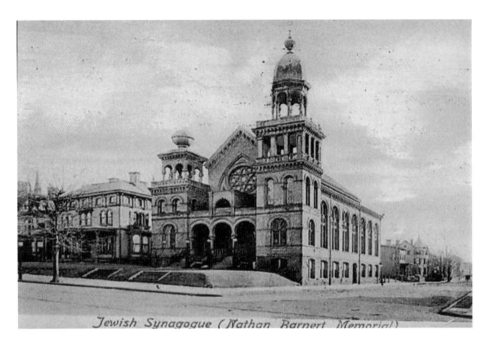

Jewish Synagogue (Nathan Barnert Memorial)

THE NATHAN BARNERT MEMORIAL CONGREGATIONAL B'NAI JESHURUN:

In 1889, Nathan Barnert deeded a plot of land on Broadway and Straight Street to the trustees of the Congregational B'Nai Jeshurun of which he was a leading member. A synagogue was to be built and designated as 'The Nathan Barnert Memorial Congregational B'Nai Jeshurun'. The only other stipulation was that upon the deaths of his wife and himself, a memorial service 'Kaddish' be held in the synagogue on each and every anniversary of their deaths. President McKinley was guest of honor at the dedication. There is now a White Castle where the Barnert Temple once stood.

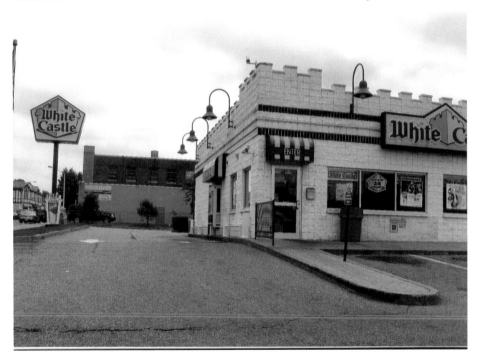

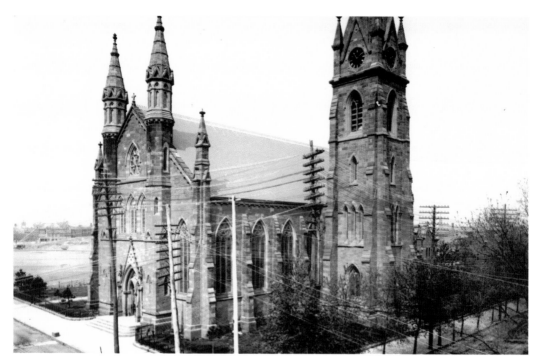

St John's Cathedral:

St John's is a Gothic style church built of brownstone that was hauled from Little Falls by way of the Morris Canal. It was consecrated in 1890. Situated on Main and Grand Streets, it was directly in front of the Colt Mansion, home of the governor of the S.U.M. Its spires dominated Paterson's skyline and still do today. It is on the state and national lists of historic sites.

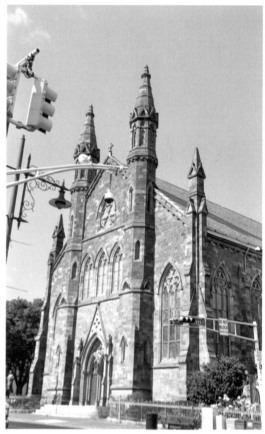

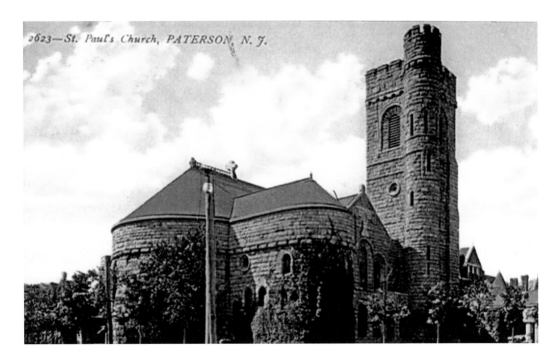

2623—St. Paul's Church, PATERSON, N. J.

St Paul's Episcopal Church: The Church was built in 1897 on what was largely farmland at Broadway and East 18th Street. It is patterned after Durham Cathedral in England with pink granite that came from the Pompton Quarry. Its pews are made of oak and Tiffany created twelve of its windows with protective covers on the outside. The Church's roots date back to 1817. In 1992, the Parish celebrated its 175th anniversary and in 1997 the 100th anniversary of the church building. In 2002, St Paul's celebrated 185 years of service.

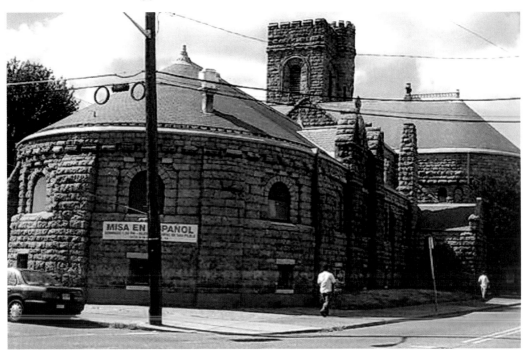

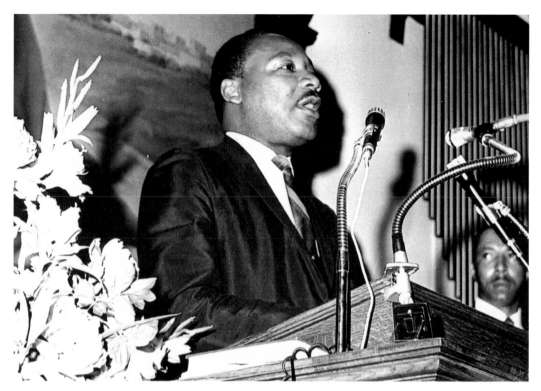

MARTIN LUTHER KING JR.:
In March 1968 hundreds of people
lined up outside the humble-looking
Community Baptist Church on Auburn
Street. Two days before he went to
Memphis, Martin Luther King, Jr.
spoke from the pulpit before a crowd of
2,200 people. Originally known as the
Holland Reformed Church, it was built
in 1887 by Fred W. Wentworth. In 1957 it
became the Community Baptist Church
until its move in 1986 to 535 Broadway.
Community Baptist Church played an
important part in Black History. Two
National African-American leaders,
Martin Luther King, Jr. and Rosa Parks
addressed the Paterson community.

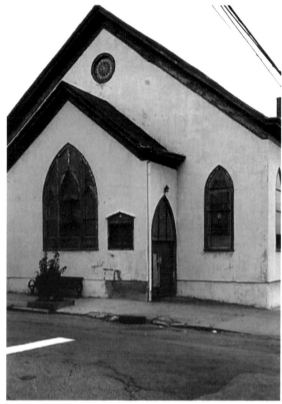

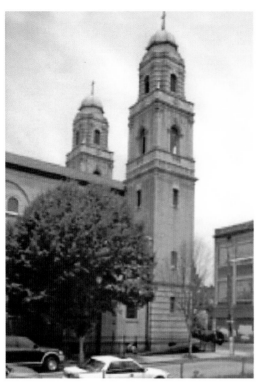

St Michael's Church:

St Michael's is located on Elm and Cianci Streets (originally Cross Street). It is similar to Spanish Colonial churches found in the west and southwest, sporting twin-domed campaniles. It is a federal and state historic site and was undergoing repairs to its exterior and interior for the past two years. September 29, 2013 marked its grand re-opening and the parish's 110th anniversary. My parents were married there in 1942 and I was baptized there in 1945 by Father Carlo Cianci.

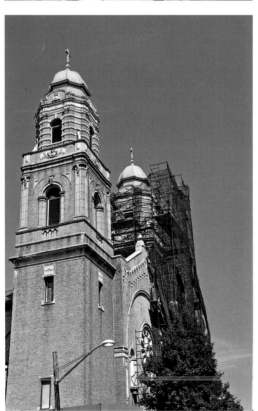

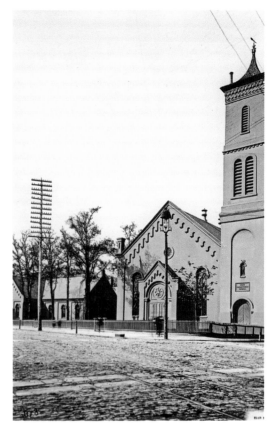

THE FIRST PRESBYTERIAN CHURCH:
The First Presbyterian Church was erected
on the corner of Main and Ward Streets in
1813. The First Presbyterian Society in town
was formed August 19, 1813. The property
was donated by the S.U.M. The Reverend
Samuel Fisher of Morristown was installed
as the first pastor in June 1814. In the fall of
1850, the church was destroyed by fire. A
new church was dedicated on November 10,
1852. Additional buildings were added to the
site within the next fifty years and are still
operational today.

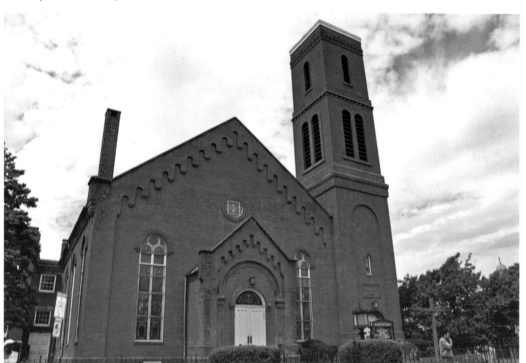

BLESSED SACRAMENT CHURCH:
Blessed Sacrament Church was founded in
1911 for Italian Catholics in the Riverside
section of the city. On July 16, 1911, the first
Mass was celebrated by Monsignor Carlo
Cianci at a building purchased on East
19th Street. Within a few years, the rapidly
growing parish purchased land on East
16th Street in order that a new church be
constructed. In 1959 a cornerstone was laid
at East 17th Street and 7th Avenue and on Palm
Sunday, 1960, the first Mass was held at the
new church, and to this day Mass has been
held there ever since.

MOVIE HOUSES AND LEGITIMATE THEATRES

At one time there were nine movie houses all within blocks of each other, all showing different distributor films with lines out the door each weekend; The Garden, the Rivoli, the Regent, the U.S., the Majestic and the Fabian. The Majestic showed vaudeville acts into the mid-1950s. Yet there is not a single trace of these scenes of Saturday matinees with *Wacky Races*, a double feature, fifty-two cartoons and a serial thrown in for the twenty-five cents it cost to enter. And at one time there was an outdoor movie theater called the Open Air Theatre at 68 Ward Street and the Bijou Theatre on West Street which is now West Broadway. Once viewed as first-rate theatrical center, Paterson earned the popular saying, 'If the production goes well in Paterson, it can go anywhere'.

The flagship of all the theaters was the Fabian. When it opened in 1925, the Fabian Theatre was modern cinematic entertainment at its best. Envisioned as a stand-alone theater, the Fabian was ultimately enclosed by the Alexander Hamilton Hotel and an office building. Seating movie and vaudeville acts, the 3,000-seat theatre boasted a two-ton chandelier, murals, tiled floors and Turkish baths in the basement. The Fabian hosted several Abbott and Costello film premieres before losing its single screen in the mid 1970s when it became a five screen multiplex in a bid to save it from closure. Returned to its former glory in 1989, the Fabian Theatre closed in 1993 after one final screening of *Robocop 3*. Ever since, city officials have tried to woo investors to bring another movie theater into town. After seventeen years, in 2010, the city has its own movie theatre again. Fabian Arena 8 opened on the upper level of the new Center City Mall that pays homage to the spirit of Paterson's robust movie-going culture. Hearing of the theatre's opening sparked a trip down memory lane for many residents who fondly recalled the bustling movie houses of their youth. Neighborhood kids would scramble over every Saturday to the movie houses in the city to watch cartoons and movies, spending most of the day there until its manager kicked them out. He went up and down the aisles saying, 'Your mother called and has supper waiting for you on the table. Go home!'

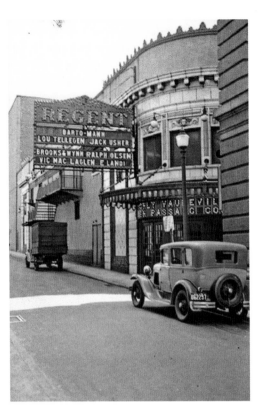

THE REGENT THEATRE:

The Regent was acknowledged as America's first picture palace built exclusively for showing motion pictures. Officially opening to the public on September 14, 1914, the Regent was located in a working class neighborhood up-town from the 'legitimate' theater district. Located between Union Street and Hamilton Street, (now a parking lot) it faced an alley similar to some NYC theaters. Doors along the wall of the theater let people go out to the alley during intermission when it was used as live theatre.

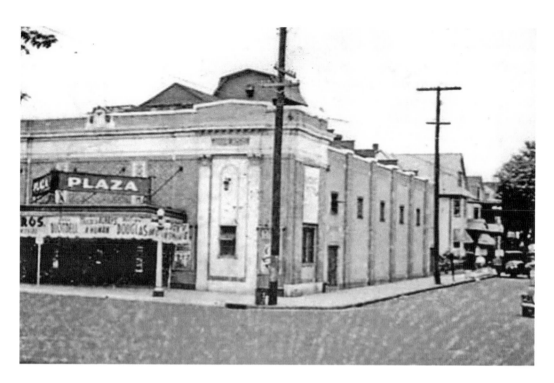

THE PLAZA THEATER: The Plaza was built in 1921 and open until 1979 showing American, Italian and Spanish movies. Host to generations of movie-goers, the Plaza was demolished in 2002, and replaced by Auto Zone. The Plaza has sentimental value for scores of current and former Patersonians. It was a neighborhood theater—a magnet for the residents of Hillcrest and Totowa where some people went on weekly 'dish-nights' when the owner would give out a piece of dinnerware to every movie-goer to drum up business.

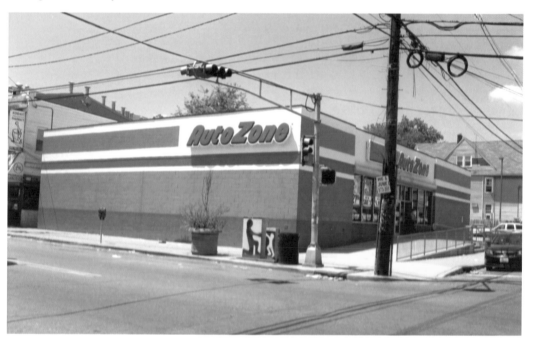

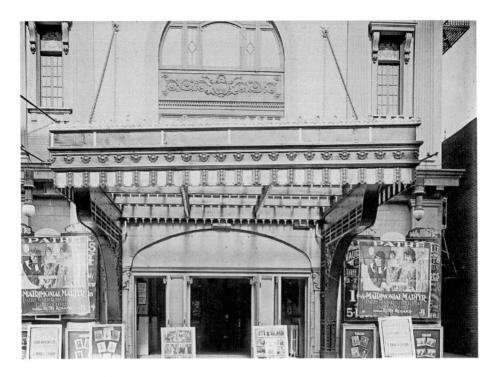

THE MAJESTIC THEATER: The Majestic was located at 295 Main Street, directly across the street from the U.S. Theatre. It was designed by Charles E. Sleight and built in 1910, by Max Gold. It was originally built for vaudeville acts, but in 1926, it switched to movies although vaudeville continued until 1952. For many years the Majestic had triple features, mainly cowboy films with stage shows thrown in at every performance—Abbott & Costello, Red Skeleton, even Elsie the Borden cow made an appearance. It was where the Center City Mall sits now and was demolished in the 1970s.

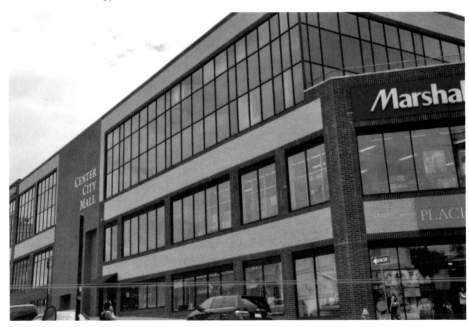

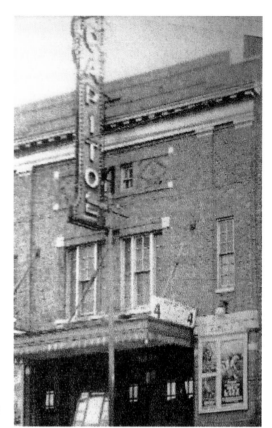

CAPITOL THEATER:

Capitol, an art-deco theater, was located on 21st Avenue in the People's Park section of the city. The movies only cost twenty-five cents for the features, cartoons and newsreels, and you could stay and watch them all over again. The building is still in use today as a boutique and immigration services.

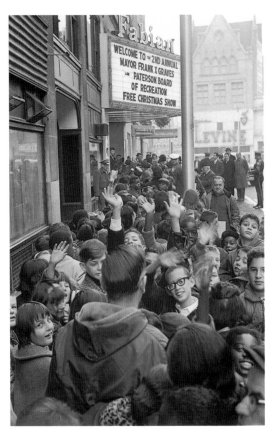

THE FABIAN THEATER:

The Fabian was the grandest and most prestigious of all the Paterson movie houses. It was the site of three Abbott and Costello world movie premieres. It was severely altered in the early 1960s for a 'modernization' and then parceled into smaller theaters in the 1970s. In the 1920s and 1930s it was a showplace. In the 1940s it was the most expensive movie house (fifty cents for adults and twenty-five cents for children) and it had the plushest seats. The theater is no longer in operation at its original site, but in 2010, Fabian Arena 8 opened in the new Center City Mall.

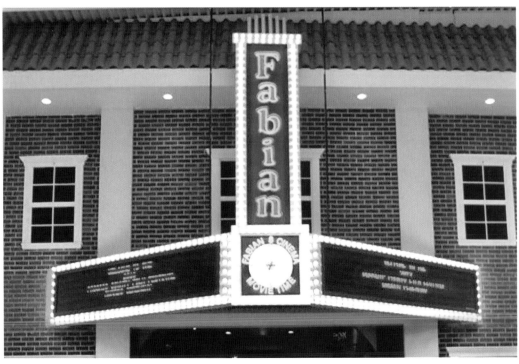

THE U.S. THEATRE:

The U.S. Theatre, opened by the Adams brothers in 1916, in the Old Walden's Opera House, had been constructed in 1866. Ushers wore dark jackets in winter and white in summer and would walk up and down the aisles carrying flashlights, telling unruly kids to put their feet down and stop disturbing patrons in front of them. There was a long tunnel just under the right aisle all the way to the back of the screen. It was for theatrical purposes for a stage magician to disappear in a puff of smoke and then run through the tunnel to re-appear at the back of the crowd.

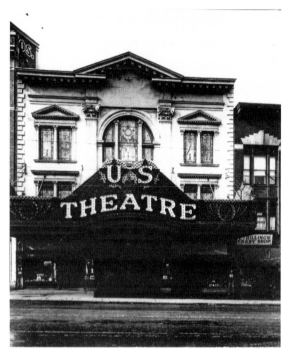

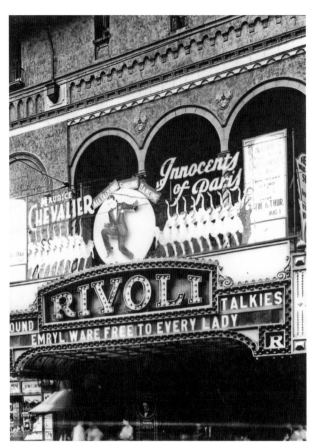

THE RIVOLI THEATER:

The Rivoli at 126-134 Main Street was located two blocks away from both the Majestic and U.S. Theaters. The Rivoli was one of four Warner Brothers theaters and creators of Vitaphone. It had a beautiful fountain on the second floor. The featured film at the Rivoli was *Innocents of Paris* which starred Maurice Chevalier. The original 'Dracula' and 'Frankenstein' played as a double feature on a Saturday afternoon plus a preview of a Charlie Chan movie and a cartoon for only ten cents. It became an Army-Navy Store and then burned down.

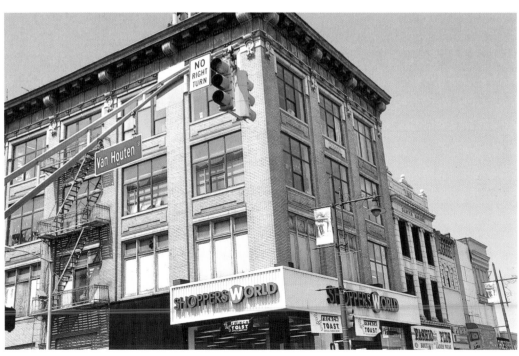

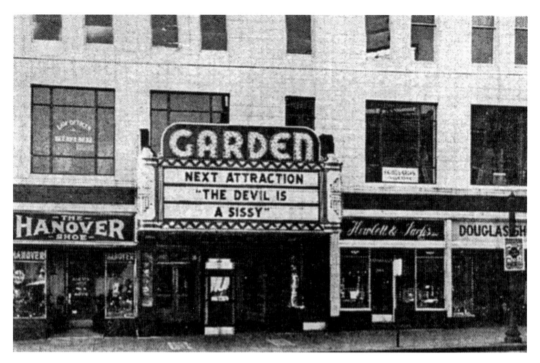

GARDEN THEATER:

Garden Theater was built in 1916 by Max Gold and later sold to Jacob Fabian. An Estey organ opus 1485 was installed in the theater in 1916 which was still operating in 1951. Demolished with other buildings along Market Street, in 1971 it made way for Hamilton Plaza, a 14-story office building among whose renters are the State of New Jersey, Greater Paterson Chamber of Commerce, Cablevision, PSE&G and the office of Assemblywoman Elease Evans.

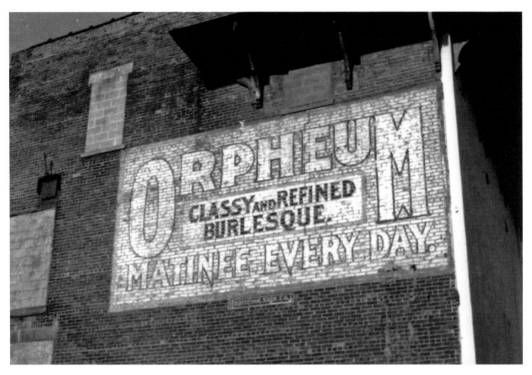

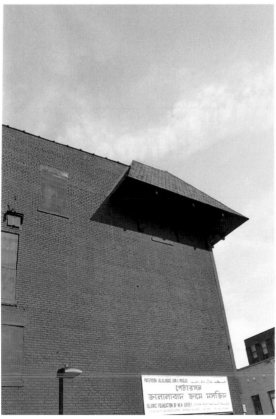

ORPHEUM:
The unique aspect of the Orpheum's façade was a fading sign on the side of the wall that said:

> ORPHEUM
> CLASSY AND REFINED
> BURLESQUE.

Among the acts that played there were Joe Besser, Sydney Fields, Lou Costello and Mae West who was taken away in a paddy wagon one night because her routine was too risqué. Located next to the Public Service bus terminal, the main entrance to the building, now owned by the Islamic Foundation, was spruced up and the old sign on the outside of the building has been painted over in green.

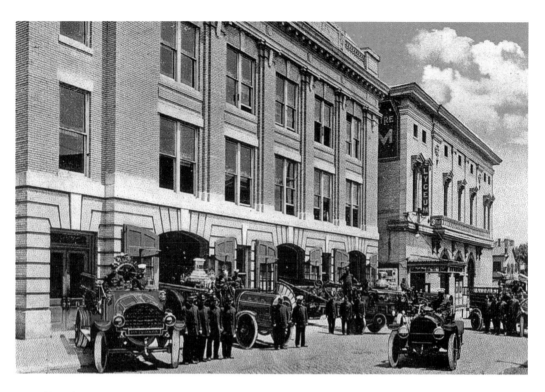

THE LYCEUM: The Lyceum was located next door to the Fire Headquarters on Van Houten Street. The building was built in 1880 but was known as Apollo Hall. It was built as a direct challenge to the Opera House but it did not survive the competition so the name was later changed to the Lyceum. Houdini appeared at the Lyceum but it is no longer in existence and is now the site of a parking garage facing Van Houten Street, Church Street and Broadway.

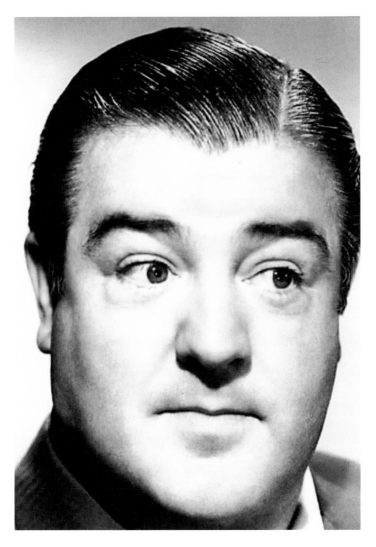

'I'M A BAAAAD BOY! I NEVER SHOULD HAVE LEFT PATERSON':

 These were lines used by Lou Costello, of the famous all-time comedy duo, Abbott and Costello, in *Abbott and Costello Meet the Invisible Man*. Nearly every one of the comedian's movies and television show contained a Paterson reference or sight gag, including his radio sign-off, 'Good night to all my friends in Paterson.' In the 'Naughty Nineties', the duo's classic *Who's On First* is performed in front of a painted backdrop of a baseball game displaying the words 'Paterson Silk Stockings'. In Cooperstown, New York, this classic routine plays non-stop in a section of the Baseball Hall of Fame Museum prominently displaying 'Paterson' on the fence. Many of Costello's movie premieres were held at the Fabian Theater, such as 'One Night in the Tropics' and 'Jack and the Beanstalk'. Lou was a die-hard Patersonian. He rebuilt the crumbling St Anthony's Church building by arranging a local benefit starring Kate Smith, George Raft, Milton Berle and Betty Grable, all major stars at the time. John Shields, a worker in Paterson's Department of Public Works, appeared as an extra in many of Lou's movies, in the 1950s. Shields played on Costello's basketball team, the Armory Five in the early 1920s. Costello's name lingers in the city. The municipal pool and a club that trains young boxers was named in his honor. His statue stands in Cianci Park on Cianci Street and part of a huge dollhouse that Lou and his father built for Costello's daughters is on display in the Paterson Museum.

HOSPITALS

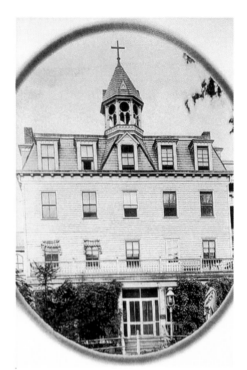

THE FONDA HOUSE:

The Fonda House was purchased in 1868 for use at St Joseph's hospital. This house sat on a farm that was sold to the Sisters of Charity of St Elizabeth who founded the twelve-bed hospital, and was located where the hospital is today. St Joseph's Regional Medical Center has grown into one of the largest medical centers in New Jersey, with nearly 1,000 beds system-wide.

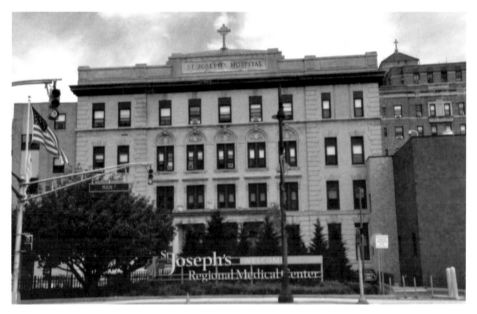

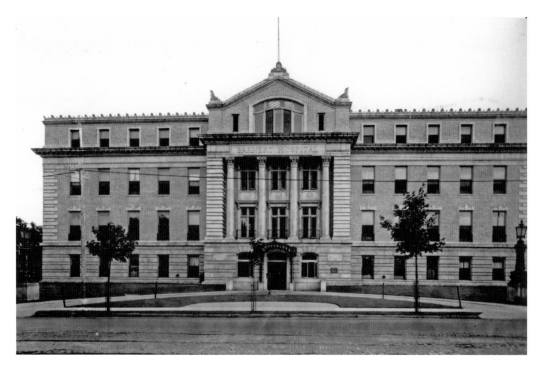

BARNERT MEMORIAL HOSPITAL: The Hospital was the first building Fred Wesley Wentworth, the architect of Paterson designed for the Jewish community. In 1914, former Mayor Nathan Barnert donated sixteen city lots on Broadway and East 30th Street and $450,000 to begin the project. The design was a classical revival building constructed of yellow brick and sporting a pink granite base. It was demolished in the 1960s for a new, more modern structure. Only a small portion of the original building is still standing. The hospital officially closed on May 30, 2008 and is now a medical arts center and houses the North Jersey Jewish Historical Society.

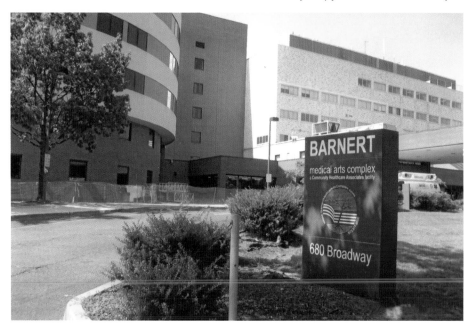

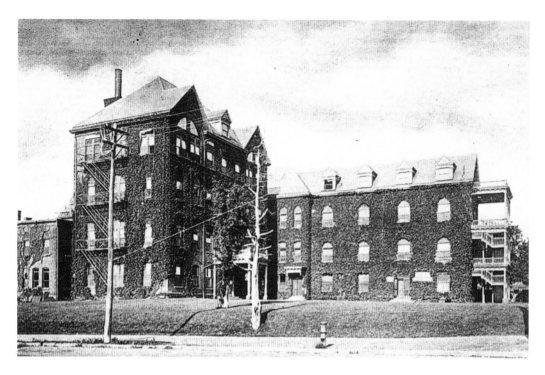

PATERSON GENERAL HOSPITAL: The Paterson General Hospital was located at the corner of Market Street and Madison Avenue. That site is now the Fire Headquarters, including administrative offices, after its move from Van Houten Street. In 1926 the Johnson Memorial Wing expanded the hospital with one of the most modern operating rooms in New Jersey.

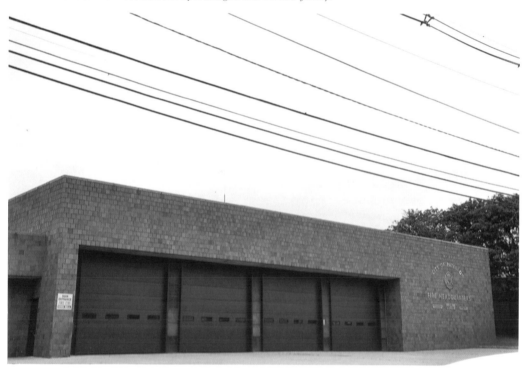

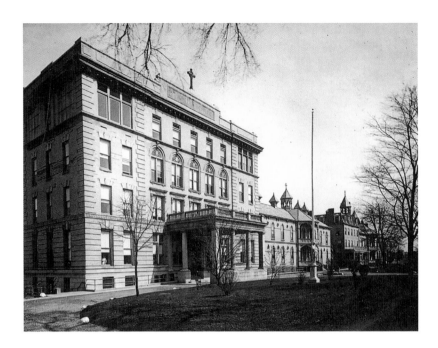

'ST JOE'S': For 100 years from 1900–2000, St Joseph's Healthcare System grew in size and customer service with major building expansion projects and advancements in technology. 'St Joe's', as it's referred to, is rich in history and has evolved from humble beginnings. In 1867, the Sisters of Charity of St Elizabeth opened the hospital on Church Street with only twelve beds. In 1898, 1,559 patients were treated and 52 babies delivered. In 1900, 300 operations were performed. A $250 million expansion has been completed and included in that expansion is a 183,000 square foot state-of-the-art Critical Care Building that features separate Pediatric and Adult Emergency Departments with a total of 88 treatment areas.

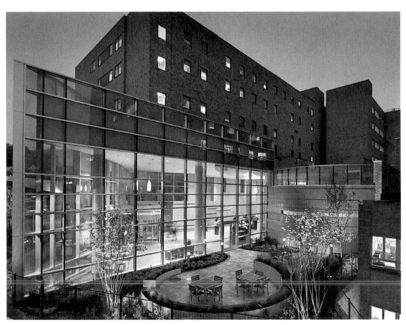

HOT TEXAS WEINERS

'One away one, one Frenchy one', a popular cry, heard from any one of the Hot Texas Weiner 'joints' in Paterson. But the most important thing to note about Texas Weiners is that they have absolutely nothing to do with Texas. Originating in Paterson at Greek-owned hot dog restaurants, a Texas Weiner is deep fried and served with Greek sauce; a smooth, slow cooked meat sauce spiced with cayenne, cinnamon, allspice, cloves and cumin. A Texas Weiner 'all the way' is served with mustard, diced onions and the chili sauce whose recipe is a closely guarded secret to this day. Greek immigrants and Greek cooking had more to do with the popularization of hot dogs and what we call chili in America than anybody else. The story of the hot dog may be more all-American than we think. Brought over from Germany, it filtered through every regional and ethnic variation imaginable.

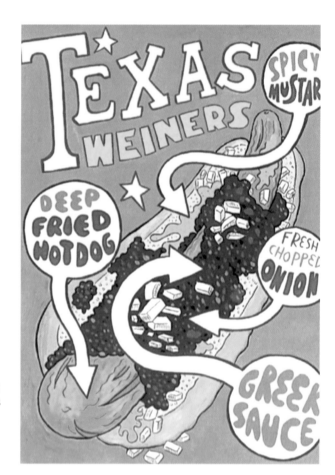

A TRUE HOT TEXAS WIENER:
The 'Texas' reference is to the chili sauce used on the 'dog'. Considered a unique regional hot dog style, it got its name from John Patrellis who created it around the turn of the century at his concession stand in the old Manhattan Hotel.

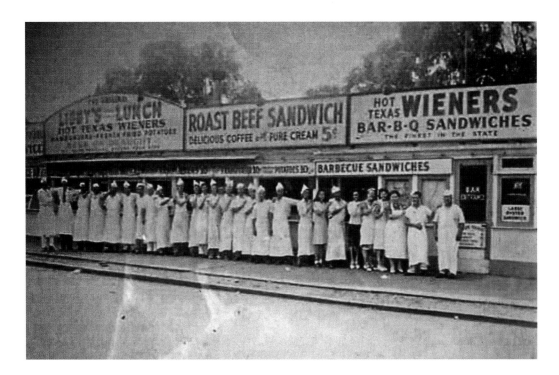

LIBBY'S LUNCH: Libby's Lunch is the oldest surviving offspring of the joints that invented the Texas style chili dog. It has been a staple in this area. A Jersey hot dog classic still operating in the same place, Libby's is a true legendary Jersey original. It has been a favorite eatery since my childhood. When you walk in, you walk back in time.

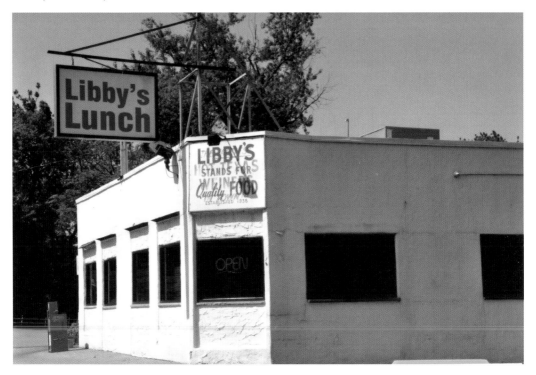

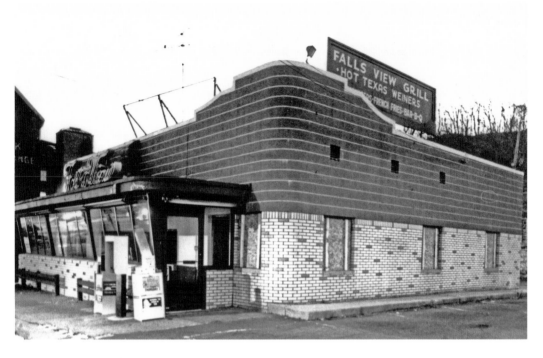

FALLS VIEW GRILL: Paul Agrusti built the Falls View himself while still working at the Olympic Grill. The foundation was formed from cement-filled iron milk crates placed side by side. When it opened hot dogs were just 20 cents and it soon became a landmark, a favorite spot for a hamburger or hot Texas weiner after high school football games. Burger King occupies the spot where the Falls View once stood and blends with the Great Falls Historic District.

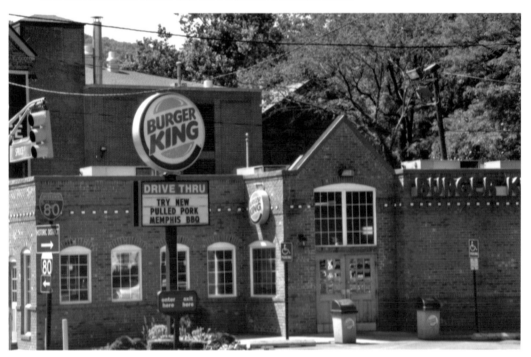

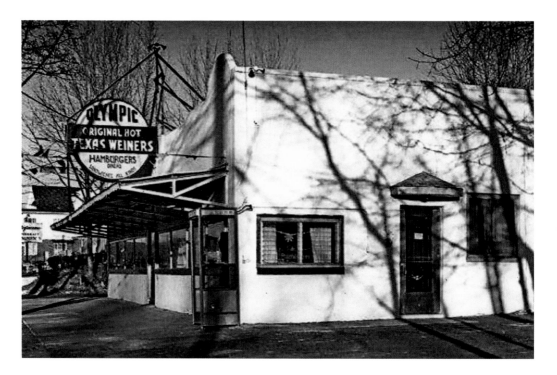

THE OLYMPIC: After returning from the Second World War, the Betts Brothers leased the Olympic Grill directly across the street from Libby's on McBride Avenue. Libby's, the Olympic, and Falls View were located within a stone's throw of one another and are considered the three most remembered Hot Texas Weiner restaurants of the post Second World War period in Paterson. There is a Dunkin' Donuts where the Olympic once stood.

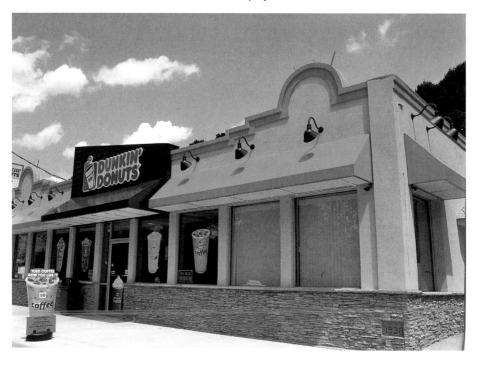

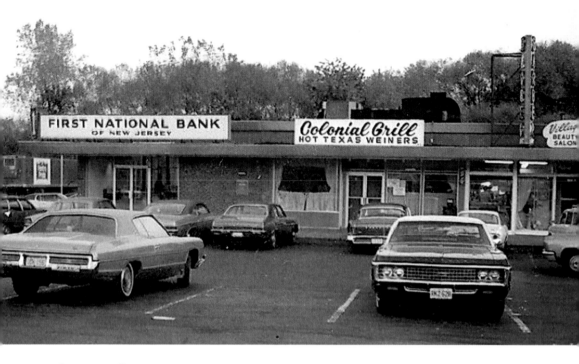

COLONIAL GRILL: Paul Agrusti who worked at the Falls View, left in 1978 to open the Colonial Grill on Chamberlain Avenue in the Totowa section of Paterson. It has changed hands several times since then, but is still operating out of the Chamberlain Avenue strip mall where it first started. It is now called 'Pep's Grill'.

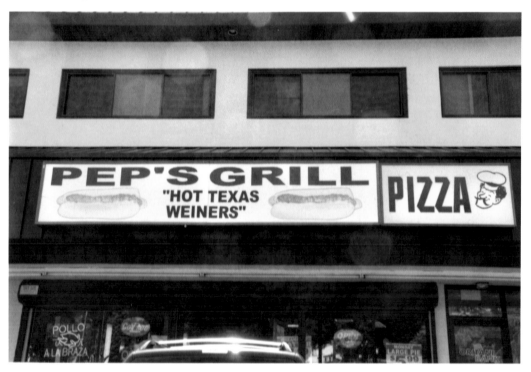

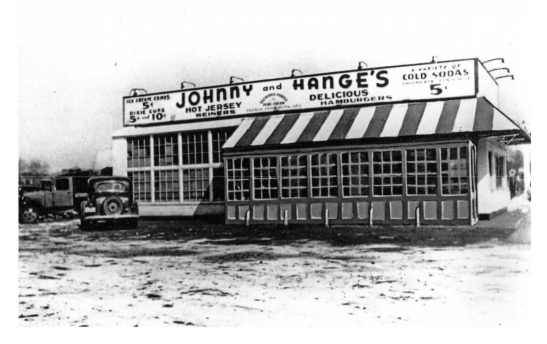

JOHNNY AND HANGE'S: On July 4, 1939, Johnny Scovish and Angelo (Hange) Mariano opened the window of their hot dog stand at 865 River Street. Seeing the lines of customers waiting to be served, they thought they were the luckiest men on the face of the earth. Customers were enjoying their famous hot Texas wieners 'All the Way'! They closed their doors fifty years later. One mile from its historic beginning, Johnny & Hange's opened at its new location on Maple Avenue in Fair Lawn in 1999, under new ownership.

HISTORIC PLACES STILL STANDING

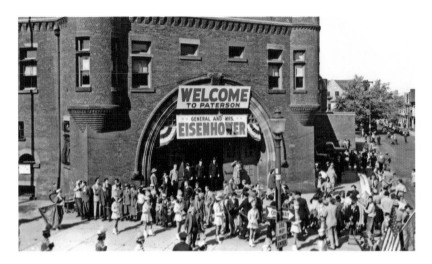

THE PATERSON ARMORY: The Armory was completed in 1895 with state funds as the first in a program to equip the cities with armories. It was home to the National Guard for ninety years. Over the years, the 75,000 square foot building, resembling a fortress presented events for all. The Paterson Orpheus Club performed Handel's *Messiah* there, Enrico Caruso sang there, Clarence Darrow spoke there, Joe Louis and Gene Tunney fought there (though not each other) and Republicans rallied for Dwight D. Eisenhower there. The last of the National Guard units moved out in the 1980s; the golden era of Paterson had long passed and the future of the armory, dimmed. Briefly it was used to store military memorabilia but after the owner failed to pay property taxes for several years, the city took ownership. It is now the subject of a grand new plan to redevelop the building for a new use.

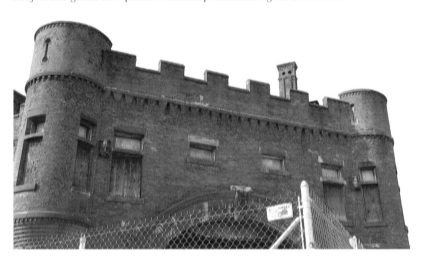

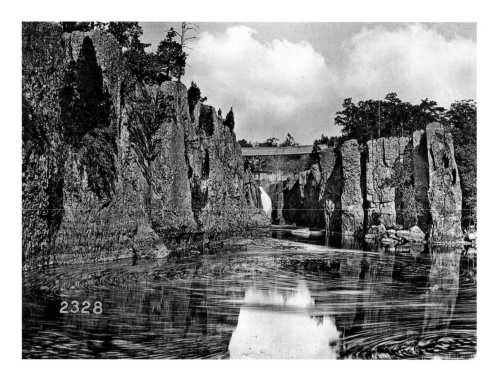

THE GREAT FALLS OF THE PASSAIC RIVER: The power behind the beauty of the Great Falls fueled the economic and social growth of a young nation. Alexander Hamilton envisioned Paterson, with its waterpower provided by the Great Falls of the Passaic River, as America's counterpart and response to the industrial revolution occurring in England during the same period. Because of this rich legacy, the Great Falls has received a number of distinctions: 1967 National Natural Landmark; 1976 National Historic Landmark; 1977 Historic Civil Engineering Landmark; 2004 Great Falls State Park and on March 30, 2009, President Barack Obama signed legislation designating the Great Falls a national historical park.

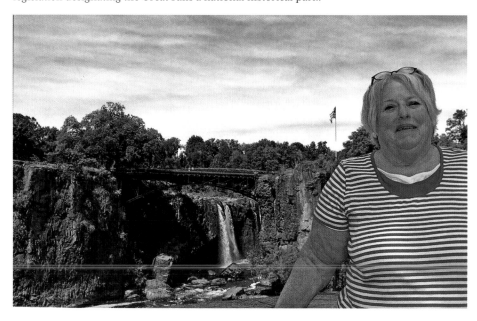

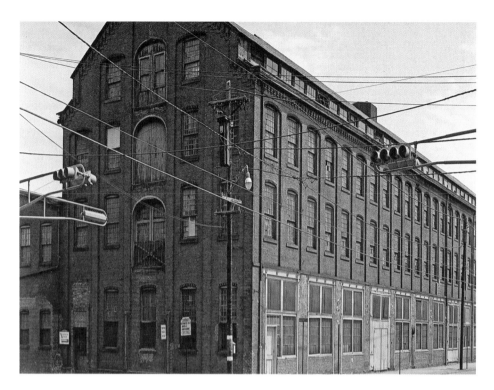

THOMAS ROGERS LOCOMOTIVE ERECTING SHOP: The erecting shop was located at 2 Market Street, and completed in 1871. It was the final stop along a locomotive assembly process that stretched through two and half blocks. The erecting shop is the oldest surviving structure of the Rogers Locomotive & Machine Works. All the equipment and machinery have been removed but its architectural character on the outside remains intact. On the Spruce Street side of the building several of the double doors are still used where completed locomotives were delivered. The building was renovated in 1982 and became the home of the Paterson Museum.

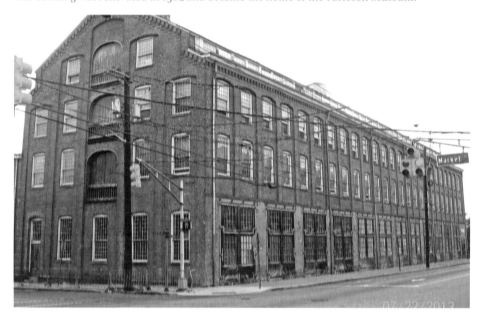

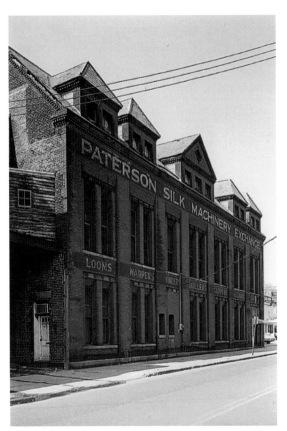

THE ROGERS ADMINISTRATION BUILDING:

This is the finest building architecturally in the historic district. The words 'Paterson Silk Machinery Exchange' are painted across its façade. It's a reminder of a later tenant. The red brick of this building is richer and deeper than the erecting shop. The windows are set deeply into a strong, solid façade, differentiating the status between the headquarters and the buildings of the working class.

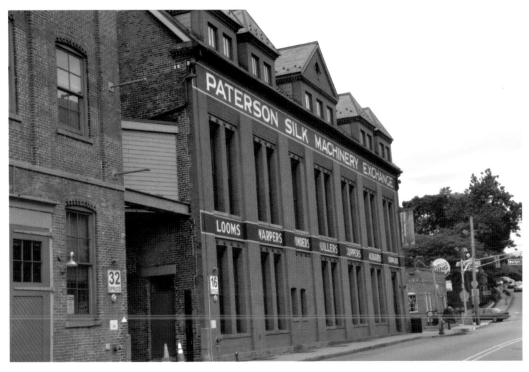

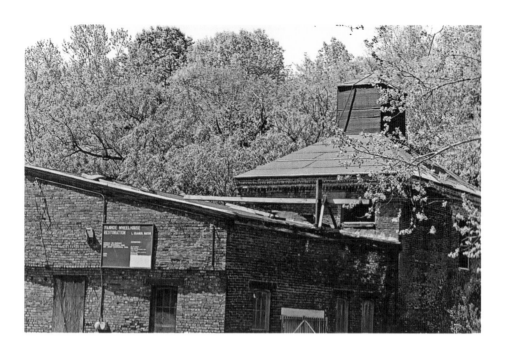

THE IVANHOE MILL WHEELHOUSE: The wheelhouse was constructed in 1865, and is nestled at the base of the upper raceway and provided power to the Ivanhoe Paper Mill Complex, one of the best-known and best-equipped paper mills in the country. There were eight to ten buildings connected with the mill and about 100 employees. The great iron doors were adorned with iron figures in relief, representing scenes from the romance of *Ivanhoe*. It produced approximately 7,500 pounds of paper a day. Today the only building left from part of the complex is home to the Ivanhoe Artists.

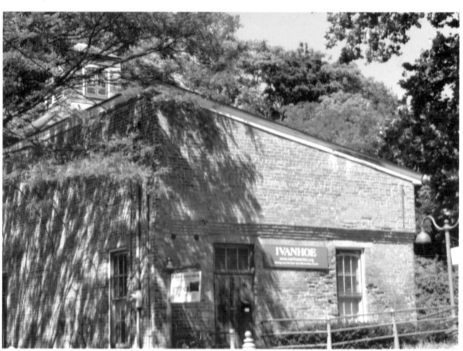

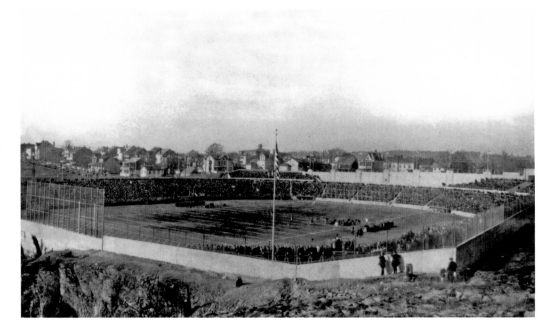

HINCHLIFFE STADIUM: The stadium was built by the City of Paterson during the Great Depression. Workers rejected by the mills found work constructing the stadium under President Franklin Delano Roosevelt's New Deal. While being constructed, Mayor John V. Hinchliffe was attentive to every detail from the art deco-style to the Gaetano Federici plaques honoring several Patersonians who had participated in the Olympic Games. Every seat was filled on opening day, July 8, 1932. In 1963 Mayor Frank X. Graves, Jr. sold the stadium to the School District for $1. Improvements were made in the 1980s but the stadium closed in 1996. It has since become blighted and abandoned.

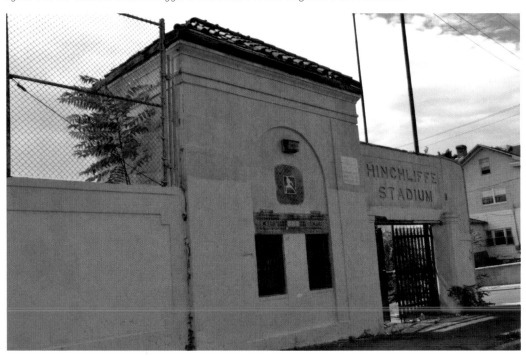

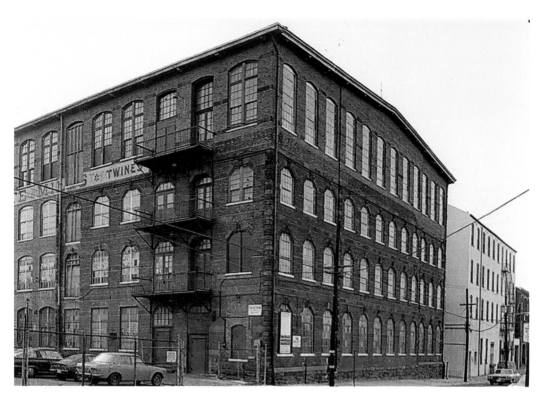

THE DOLPHIN JUTE COMPANY: A complex of buildings in the Great Falls Historic District at 70 Spruce Street, the Company was one of the largest manufacturers of rope, twine and carpet backing from hemp and jute and was a part of Paterson's industrial past. The Company occupied some of the Rogers Locomotive Works' buildings along with the Paterson Silk Exchange when Rogers ceased operation. It now serves as a venue for The Ivanhoe Artists and is known as the Art Factory.

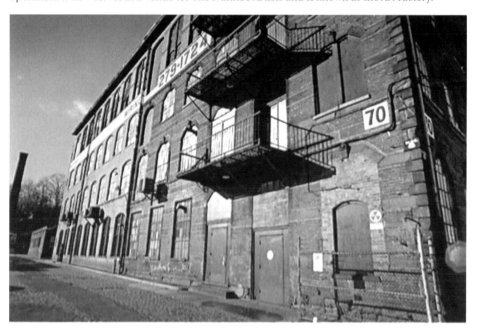

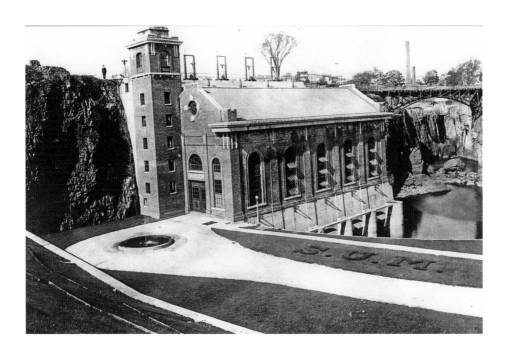

THE HYDROELECTRIC PLANT: The Hydroelectric Plant completed in 1914 sits below the road at the bottom of the falls. There is a great, cathedral-like space inside, containing four immense penstocks or water intakes and four turbines. It replaced the waterwheels that supplied power to the mills. The plant was restored in 1984 with the replacement of three of the four turbines. In 1986, the plant was re-started to generate electricity to homes and businesses throughout the region. Plans to increase its energy production are in the works. It is a potent reminder of the great power and strength of industrial architecture that one could ask for.

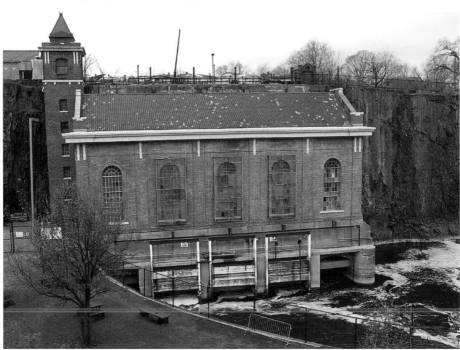

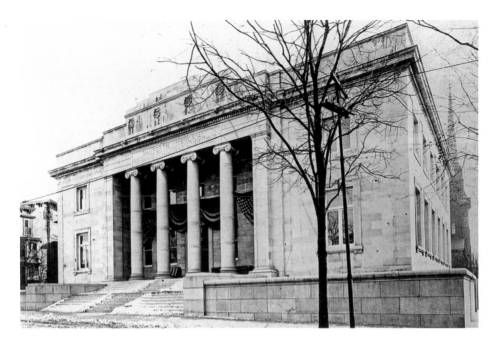

DANFORTH MEMORIAL LIBRARY: The Library was established in 1885 and is the oldest public library in New Jersey. 54 Church Street was the location of the first library, and the former home of the Charles Danforth family at Church and Market Street was the second location. It was given to the city by Mary Danforth Ryle in memory of her father. A substantial expansion of the library was to be financed by Mrs Ryle, but the Great Fire of 1902 destroyed the building. Once again Mrs Ryle donated funds in her father's memory and as a memorial to him and its present site at 250 Broadway was chosen for the building. Henry Bacon, who designed the Lincoln Memorial, designed the Danforth Memorial which opened in 1905.

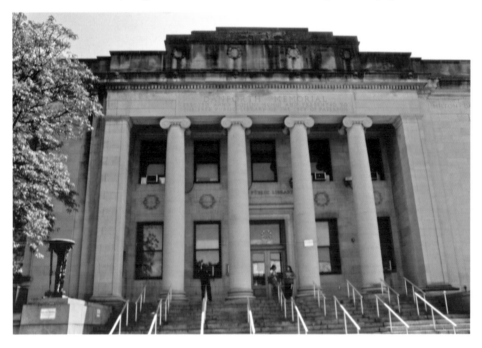

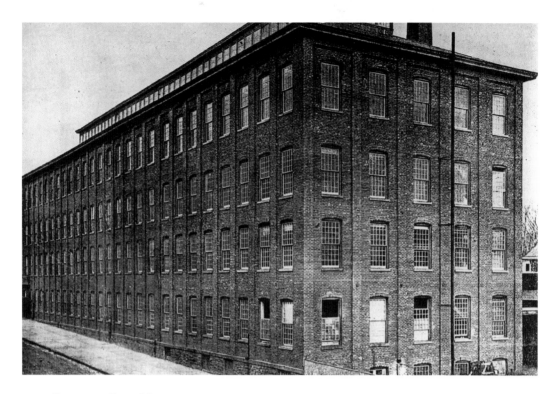

DOHERTY SILK MILL: Doherty Silk Mill is where the silk strike of 1913 began, when 800 broad silk weavers walked off the job. It was one of the largest and most modern silk mills on the south side of town (Lakeview section). The silk company modernized the mill in 1911 to a multiple loom system, upsetting workers who feared the inevitable loss of jobs. The strike ended in failure on July 8, 1913. The building is still in use today at the Paterson-Clifton border and there are many small companies using the space.

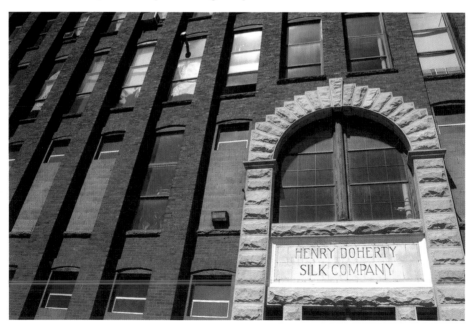